watercolor
painting outside the lines

a positive approach to negative painting
Linda Kemp

NORTH LIGHT BOOKS
CINCINNATI, OHIO
www.artistsnetwork.com

ABOUT THE AUTHOR

A full-time artist, Linda Kemp frequently instructs and lectures at national symposiums and watercolor workshops throughout Canada, the United States and the United Kingdom.

Her paintings and articles have been featured in *Color and Light for Watercolor Painters* by Christopher Schink and *Twenty Wonders* edited by Sean Charlebois; in art publications such as *International Artist, Watermedia Focus, Palette Magazine,* and *The Watercolour Gazette*; and on the television program *Watercolour Workshop*. Linda is a contributor for Jack Reid's newest (spring of 2004) North Light book, *Watercolor for the Fun of It, Easy Landscapes*. She also has an instructional video, *Watercolor—Painting Outside the Lines*.

She is an elected member of the Canadian Society of Painters in Watercolour, the Ontario Society of Artists and the Society of Canadian Artists, and was awarded an honorary membership into The Society for All Artists. Linda is profiled in *Canadian Who's Who* (University of Toronto Press, 2003), *Who's Who of Canadian Women* (Toronto Press, 1999), *The Dictionary of International Biography* (Houghton Mifflin, 2003), *The 20th Anniversary Edition of Trivial Pursuit* and *2000 Outstanding Intellectuals of the 21st Century*. Her award winning work is in private, public, and corporate collections around the world, including The Royal Collection, Windsor Castle, U.K.

Linda's home and studio are nestled in the woods on the Niagara Escarpment in southern Ontario, Canada. More of Linda's work can be seen at www.lindakemp.com.

Watercolor Painting Outside the Lines. Copyright © 2003 by Linda Kemp. Manufactured in China. All rights reserved. No part of this book may be reproduced in any form or by any electronic or mechanical means including information storage and retrieval systems without permission in writing from the publisher, except by a reviewer who may quote brief passages in a review. Published by North Light Books, an imprint of F+W Publications, Inc., 4700 East Galbraith Road, Cincinnati, Ohio, 45236. (800) 289-0963. First paperback edition 2008.

Other fine North Light Books are available from your local bookstore, art supply store or direct from the publisher.

12 11 10 09 08 5 4 3 2 1

Library of Congress has catalogued hardcover edition as follows:

Kemp, Linda.
 Watercolor Painting Outside the Lines : A Positive Approach to Negative Painting / Linda Kemp.—1st ed.
 p. cm
 Includes index.
 ISBN-13: 978-1-58180-376-1 (hc. : alk. paper)
 ISBN-10: 1-58180-376-1 (hc. : alk. paper)
 1. Watercolor painting—Technique. 2. Form Perception. I. Title.
 ISBN-13: 978-1-60061-194-0 (pbk. : alk. paper)
 ISBN-10: 1-60061-194-X (pbk. : alk. paper)

ND2422.K45 2004
751.42'2—dc22 2003059267

Content edited by James A. Markle
Production edited by Gina Rath
Designed by Wendy Dunning
Production art by Christine Long
Production coordinated by Mark Griffin

fw
F+W PUBLICATIONS, INC.

Metric Conversion Chart

To convert	to	multiply by
Inches	Centimeters	2.54
Centimeters	Inches	0.4
Feet	Centimeters	30.5
Centimeters	Feet	0.03
Yards	Meters	0.9
Meters	Yards	1.1
Sq. Inches	Sq. Centimeters	6.45
Sq. Centimeters	Sq. Inches	0.16
Sq. Feet	Sq. Meters	0.09
Sq. Meters	Sq. Feet	10.8
Sq. Yards	Sq. Meters	0.8
Sq. Meters	Sq. Yards	1.2
Pounds	Kilograms	0.45
Kilograms	Pounds	2.2
Ounces	Grams	28.3
Grams	Ounces	0.035

ACKNOWLEDGMENTS

I would like to express my appreciation to the many individuals who have patiently helped and encouraged me in the preparation of this book. Particular thanks must go to the talented Lisa Welch Riggs for her assistance with my original manuscript and to Archie Hood for his photographic expertise and guidance. Special thanks to Jack Reid, Gordon MacKenzie and Christopher Schink for their unfailingly good advice. I am grateful to Barbara McKay and Tim and Doug Hopper of H.K. Holbein for their generosity and support. In addition, John Heikkila, Larry Barton, Anthony Batten, Marijke and Harriet McCaig, and Susanne and David Massie, all of whom provided much assistance and contributions.

It has been my great fortune to have the pleasure of working with my editors James Markle and Gina Rath. I also appreciate the skills of Pam Wissman and the creative staff at North Light Books.

Thanks also to my enthusiastic students who prompted me to assemble my ideas and who continually encourage and challenge me in developing and fine-tuning the strategies and exercises that are the foundation of this book.

I extend a heartfelt thank you to my beautiful children, Jamie and Eric, for their assistance and understanding throughout my severe obsession with this book, and to my parents, GiGi and the Frayne gang, who believe in me even when I am unbelievable.

Most of all I'd like to thank my husband and partner, Barry, for putting up with me and all of my "big ideas." My dreams and schemes always end up meaning more work for him, as when minor house repairs became major renovations or a little landscaping project required a backhoe. This book is no exception. Barry has assumed the tasks of grocery shopping and laundry without complaint. He has become a terrific cook and housekeeper during the many years that it has taken to pull this book together.

DEDICATION

To Jamie, Eric and Barry: you are the light that brings color to my life.

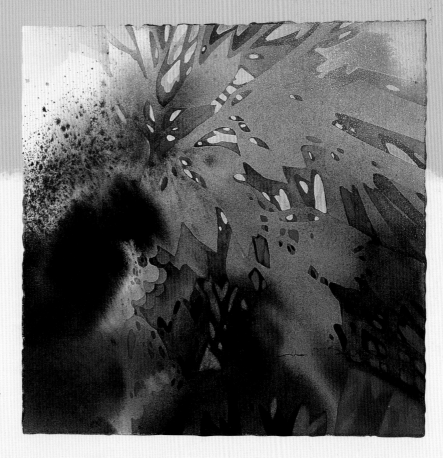

LIGHTS THAT SPARK AND FLY
Watercolor
11" × 11" (28cm × 28cm)
Private collection

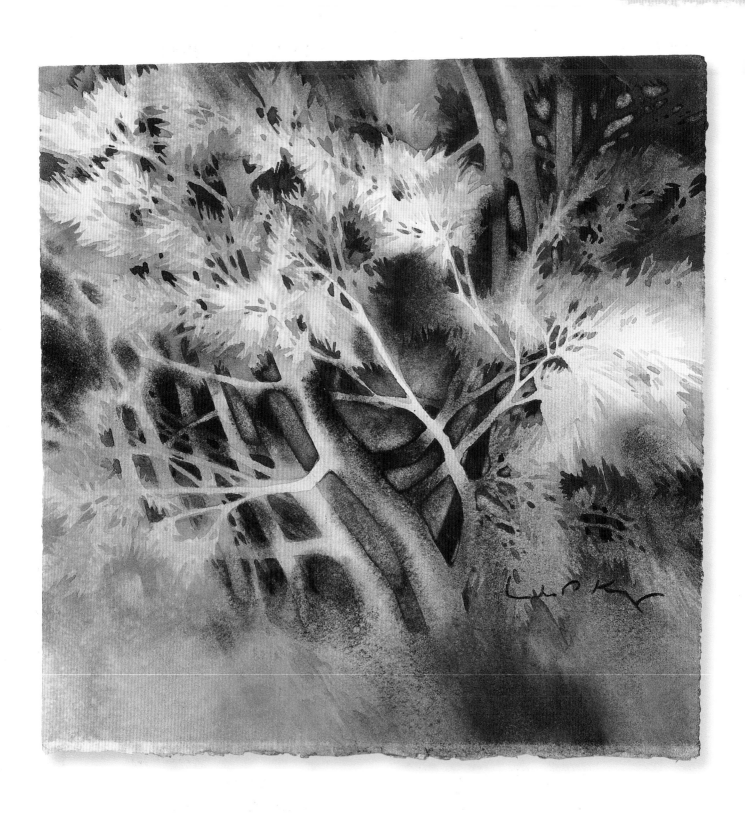

DID GENTLY KISS THE TREES
Watercolor
11" × 11" (28cm × 28cm)

TABLE OF CONTENTS

1 basic *painting supplies*

To accomplish these projects and paintings you need only be armed with basic painting supplies, many of which you may already possess.

2 underpaintings— *laying the groundwork*

An underpainting is the foundation or groundwork on which you will build your painting. These exciting beginnings are as personal and expressive as the individual who creates them and can be approached in a variety of ways, implementing a broad spectrum of techniques.

3 getting *into shapes*

Become a shape maker—you will simplify and greatly improve your artwork. By designing with shapes, instead of attempting to recreate things, you can produce creative and original artworks and make the experience of painting more rewarding and satisfying.

4 working with glazes *and building layers*

These projects have been designed to teach you how to weave your negative shapes together and to build with layers for a variety of subject matter. Along with learning how to glaze colors, you will discover two different strategies for working in the negative: how to develop florals and still life arrangements by working from the front to the back and how to build landscapes from the ground up.

5 building nature's *complex shapes*

In this chapter you will find some straightforward strategies that simplify the task of depicting complicated, compound shapes and unravel the network of interwoven layers. These projects will show you how to make complex natural forms easy to paint. The secret is to start by planting one idea and then allowing it to grow.

6 picture planning *made easy*

Picture planning doesn't have to be painful. In fact, I'm hopeful that you will find my rather unsophisticated approach to designing your art logical and easy to use. This section will not teach you everything there is to know about design. Instead, its purpose is to offer up a user-friendly strategy, so that you will be comfortable setting aside a few moments to consider design options that will help you produce more effective and successful paintings.

7 assembling *the pieces of the puzzle*

It's time to put all of the pieces of the puzzle together. In this section you will follow along with demonstrations of three different subjects. All are developed by building layers of negative shapes and glazing. Each painting begins using a worksheet and a planned underpainting that reflects my interpretation of the selected moods. The subjects evolve following the lessons found throughout the earlier chapters.

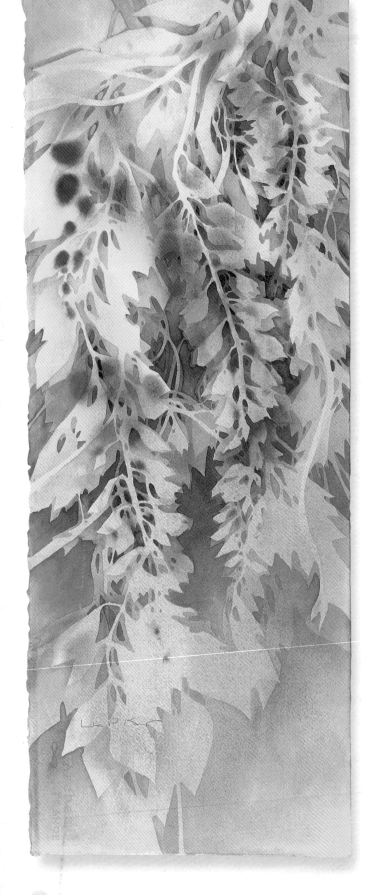

Quietly the young artist crept through the dark corridor into a large cavernous room. In his hand he held a delicate, hollow tube filled with dark pigment. Pressing the fingers of his right hand against the rough wall he flattened his palm against the cold surface. Placing the tube against his lips he blew softly, propelling a fine spray of powder over and around his hand. Withdrawing his spattered hand, he inspected the negative image that remained on the rock; one solitary imprint among a myriad of others. There his handprint would remain, hidden in the dark caves of Cosquer, France just north of the Mediterranean Sea. It would be approximately 27,000 years until that impression and those of other adults and children would come to light. These black sooty markings are the earliest known examples of images produced in the negative.*

From France and Spain, to Australia, South Africa, Ethiopia, Brazil and the Sahara Desert, negative handprints have been discovered by numerous adventurers and speleologists. Such images have also been found in the states of Arizona and Utah. The stenciled hands made by Paleolithic man were created with the most basic materials: black carbon or red iron oxide finely ground between slabs of stone, and blown through hollow bones or reeds. The hands, separated by thousands of years and thousands of miles, are veiled in mystery. Were they mere decoration, or part of hunting rituals? Perhaps the handprints were solely verification of the artist's existence.

SHAPE ON SHAPE—WISTERIA
Watercolor
11" × 30" (28cm × 76cm)

*Chauvet, Jean-Marie, Eliette Brunel Deschamps, Christian Hillaire, *Dawn of Art: The Chauvet Cave—The Oldest Known Paintings in the World*. New York: Harry N. Abrams Inc., 1996.

When I began painting with watercolor, and for many years that followed, I concentrated on trying to recreate objects exactly as I thought they looked. The strategy was to reproduce the subject—a tree, a house or an animal—by capturing all the small details and characteristic textures, and by matching identical colors. I believed that if I got all of these right I would have a good picture. I practiced the various maneuvers that I read about in a multitude of instructional books, trying to produce interesting effects with sponges, salt, plastic wrap, knives and a strange variety of miscellaneous kitchen implements. Brushes were purchased for specific duties; one for barn board texture, another for fine branches, and yet another broad, flat brush for skies. Mastering the tricks and skills was simple and fun, but no matter how expertly I would manipulate the paint or scrub, scrape and scratch at the paper, I didn't produce truly satisfying, personal statements. It took many paintings for me to realize these tactics were simply techniques, and that in order to become a better and more creative artist, what I needed to explore and understand was something beyond how to put the paint on the paper.

I have learned that creativity isn't about inventing unusual or eccentric ways of applying paint, but rather more about finding my own way of seeing and visualizing, and working toward developing a clear, honest voice with which to express my ideas. Discovering the beauty and strength of simple shapes and patterns was a big step towards my artistic goal.

The intent of this book is to demystify negative painting for both beginners and accomplished artists alike. I wish to open up a world of new-found vision, innovation and creativity. I hope to show you an alternative approach that you can easily add to the way you already paint, no matter what that style might be. I want to help you increase your ability to see in a clearer, more focused way while expanding your artistic repertoire. To that end, this book consists of a collection of exercises and projects, many of which I teach in my classes. Although a set of exercises may suggest conformity, the end goal is one of diversity and personal expression. The progression of projects is arranged to take you step-by-step through a course of dis-

covery that will lead to developing successful and satisfying paintings. I have chosen primarily to use watercolor throughout this book; however, as evident throughout history, the negative approach can be applied to all painting mediums, printmaking and sculpture. When you are ready to begin, I recommend that you work through the book in order of presentation. Each exercise leads to the next, yielding a fresh approach to watercolor. Although some of the exercises may seem elementary, I believe it is necessary to experience and appreciate each step along the path. There are many things to be discovered. Embrace painting as a joyous expedition. As you travel along a road of discovery there are many pathways to be investigated. In writing this book, it is my aim to provide you, the explorer, with a map to guide you along just one of the many possible routes that you may take on your journey.

Preparing and gathering my ideas together for this book has been a wonderful challenge. While sharing my thoughts and literary ideas with students, friends and colleagues, I have been met with the obvious question, "What is your book about?" My usual response, "Negative painting," was occasionally followed by "You shouldn't call it negative painting, it sounds so negative!" My dictionary defines the term *negative* as used to express denial or refusal and denotes a lacking of positive or distinguishing qualities. It is little wonder that the phrase *negative painting* is viewed with apprehension or, dare I say, negativism.

In an attempt to establish a more optimistic term to describe the approach I employ when painting, I challenged a group of my students to define the process with a less pessimistic label. With utmost enthusiasm, the class rose to the task. I now have a great and ever-increasing list of eloquent and affirmative descriptions: counter painting, inverse painting, converse contour, reverse positivity, inverted positive, counter positivity, reflected positive, unconventional positive, transposed imaging. The trouble is, every time I use one of these romantic sounding expressions, somewhere, someone, after a long thoughtful pause asks, "Do you mean *negative painting*?"

"Absolutely, positively!"

Think positive—paint negative!

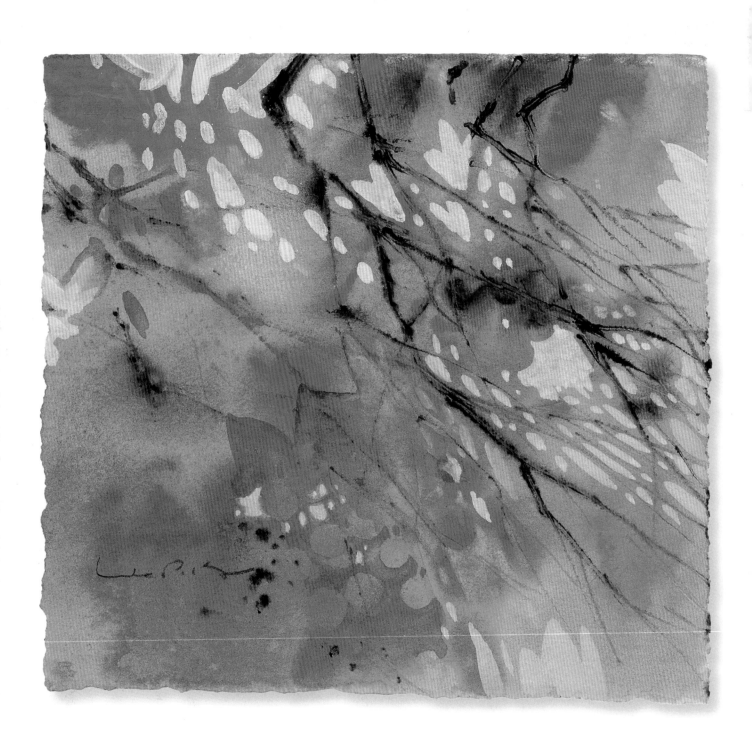

IN A WHISPER
Mixed water media
8" × 8" (20cm × 20cm)

basic
painting supplies

1

Painting in the negative is the main focus of this book—how to manage this approach and how to succeed at it. To accomplish these projects and paintings you need only be armed with basic painting supplies. If you have previously worked in watercolor, you most likely already possess most of the materials required, with the possible exception of a piece of Plexiglas. It isn't necessary to use the most expensive equipment, although it is important always to employ good quality paint and paper that have been proven for reliability and performance. Working with inferior products can be extremely frustrating, since the final outcome is directly influenced by the behavior and individual characteristics of the materials. There are no brushes or paints that can guarantee fantastic results and the tools that work well for one artist may feel clumsy to another. Through experimentation you will discover which products, pigments and personal color choices complement your purpose and style of working. Only practice and persistence will provide the skills to turn awkward brush marks into elegant strokes.

painting supplies

I know of no greater source of temptation to an artist than the vast array of enticing treasures found in art supply stores and catalogs. With the hope and anticipation of masterful artworks yet to be created, many engrossing hours can be spent perusing these delights. The seductive lure of new colors and miraculous products makes the investment of large sums of money a common addiction for many of us. You can easily fill your studio and empty your pockets, but what are the essentials? All we really need are a few brushes, some paint, a palette for mixing, paper and a sturdy work surface. Briefly, here are the supplies that work for me.

Brushes

All you need to begin painting is a small assortment of good quality brushes. A 1½-inch (38mm) flat brush is great for cutting around shapes and is my all-time favorite brush. I use nos. 8, 10 and 12 round brushes of sable or sable-synthetic mix for creating captured negative shapes and painting around shapes. Both ends of the sable signature and/or rigger-type brushes, nos. 4 or 6, can be used to make sensitive marks and fine strokes. A 1-inch (25mm) bristle is a heavy-duty brush that creates beautiful textures. I also keep an assortment of inexpensive and worn-out bristle brushes for spattering, scrubbing and producing texture.

Paint

I use only tubes of artist-quality watercolor. I love to work with freshly squeezed paint. I find it more exciting and potent than reconstituted dried nuggets. More than just choosing particular hues, my pigments are selected for their individual and specific characteristics. I use paint from a variety of different companies: Holbein, Winsor & Newton or DaVinci Paint Company. The quality is more significant than the brand name. I recom-

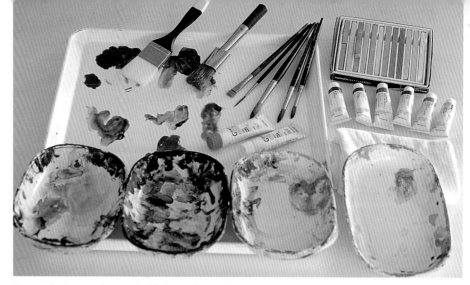

Here are just some of the materials I use when painting.

mend buying large tubes to encourage bold assaults. It's difficult to paint in a loose or aggressive manner when you're stingy with paint and paper.

Palette

For studio work and traveling, my palettes are small white ceramic dishes, the same type as you might use to bake individual casseroles in. I use one palette each for transparent staining and transparent non-staining, and two dishes for opaques (warm and cool colors are separated). By segregating my pigments, I find it easy to maintain control over the way my paints behave. I never have to worry about making unwanted mud, polluting a transparent with an opaque or mistakenly applying unforgiving stains. For mixing, I also use a larger surface such as a white butcher's tray or a ceramic platter, or I simply lay my paints out by squeezing them directly onto the surface of my Plexiglas tabletop.

Paper

When building multiple layers of glazes, as in most of the projects in this book, it is imperative to use good quality 100 percent rag watercolor paper. The use of machine-milled pulp papers in coil pads or soft-surfaced highly absorbent papers will only lead to disappointing results. My current choices are 140-lb. (300gsm) or 300-lb. (640gsm) cold- or hot-pressed Arches

and 200-lb. (425gsm) Saunders Waterford watercolor papers. Lighter paper, 90-lb. (190gsm), is acceptable for tests.

Plexiglas and Boards

I don't stretch, tape, clamp or staple my paper. Nor do I purchase expensive pre-stretched blocks. I merely wet my paper and place it on a sheet of Plexiglas. You may be able to purchase a scrap or a second quality piece from a glass or hardware store. It should be slightly larger than the dimensions of the paper you like to work on. I keep several pieces of different sizes on hand including one large enough to cover my tabletop. For drying I lay wet underpaintings on wooden boards, such as a piece of plywood or particleboard.

Additional Equipment

Along with my painting supplies, I keep a large bucket of clean water, paper towels, cotton rags, a spray bottle filled with water, a handheld hair dryer and a painting apron handy. I'm ready for a masterpiece or a mess.

I am not a purist when it comes to watercolors and I encourage you to experiment with pastels, acrylics, acrylic gouache, watercolor crayons, pencils and so forth. If you like the effects that you create using these other mediums, by all means indulge.

tearing lightweight paper

Rather than cutting, I always tear the paper against a straight edge to create a delicate deckle edge. Creating a rough edge gives your painting a more natural and handmade appearance. Use this technique to create a deckle edge on a piece of 200-lb. (425gsm) or lighter weight paper.

When finished, the beautiful edges of your painting can be accentuated by float mounting.

supplies	200-lb. (425gsm) or lighter watercolor paper	T-square or sheet of Plexiglas

1 MEASURE AND ALIGN YOUR PAPER
Begin by measuring the desired dimensions and indicating them on your paper with a small pencil mark. Position your watercolor paper squarely along the edge of the table. Place a T-square against the table. The bottom edge of the paper, the T-square base and the table edge should be aligned. Align the straight edge with your indicator mark. If you don't have a T-square, use the side of a sheet of Plexiglas.

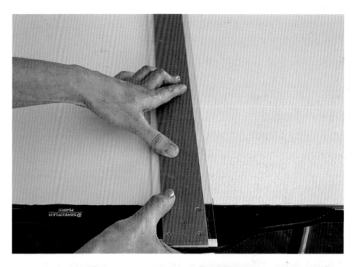

2 TEAR THE PAPER
Firmly place one hand at the top of the T-square or Plexiglas and apply steady pressure. Grasp the free edge at the top of the paper and pull it towards you, tearing the paper against the sharp bottom edge of the T-square or Plexiglas.

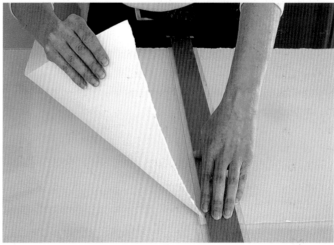

3 CONTINUE TO TEAR THE PAPER
Move your fingers down the T-square as you tear the paper, maintaining solid pressure to anchor the cutting edge and avoid slippage. Tear only a few inches at a time, stopping to adjust your hand as necessary. That's all there is to it.

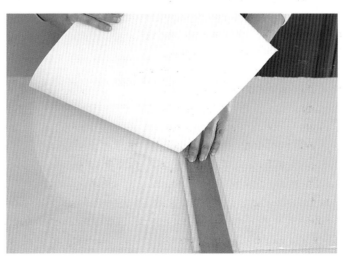

Practice tearing scrap paper first.

13

tearing heavy paper

Not only does tearing produce a beautiful edge but, once you get the knack of it, tearing is easier and faster than cutting. This process can be used when tearing paper 200-lb. (425gsm) or heavier.

supplies	200-lb. (425gsm) or heavier watercolor paper	T-square or sheet of Plexiglas
	Craft knife	

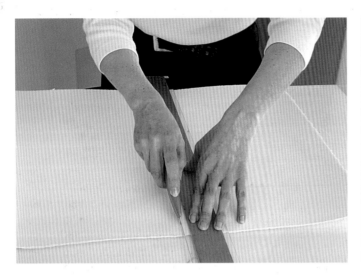

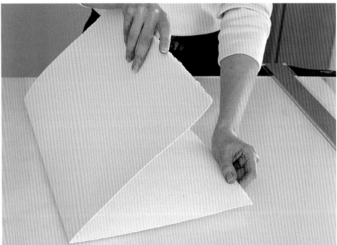

1 SCORE THE PAPER
Lightly score the paper using a craft knife. Do not cut through the paper.

2 BEND THE PAPER
Gently bend back the paper at the scored groove.

3 TEAR THE PAPER
Flip the paper over and nestle the folded edge against the straight edge and tear while applying firm pressure as with the lighter paper.

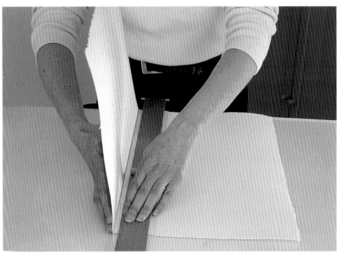

getting to know pigment qualities

Educated decisions usually prove the wisest. When you select a color to apply to your painting, there are many factors you need to consider. Frequently inexperienced painters choose colors that appeal to their eye, unaware of the specific qualities each pigment possesses. However, not all pigments behave in the same way. For predictable and satisfying results it is necessary to acquire a clear understanding of how and why paints perform. To this end, I have provided a basic description of the categories as they pertain to the painting approach in this book. In this section you will find simple, easy to

follow tests that you can conduct in order to understand and classify your paints. You will also see microscopic enlargements of pigments from each category that will give you insight about why different pigments behave in certain ways.

While watercolors are generally considered transparent, many are most certainly not. To achieve the most successful results when working with this medium, you need to become familiar with the terms transparent, opaque, staining and nonstaining, and how best to take advantage of these different attributes. When you create paintings that require multiple

layers, as in most of the projects in this book, it is essential to know which paints are best suited for glazing. To introduce highlights or correct problem areas by lifting color, it is necessary to choose paint that can easily be removed, or alternatively, with which dense opaques can be employed. When creating rich darks and certain other interesting effects, try recruiting staining colors. With a fundamental understanding of the natural qualities of pigments, you will be able to work with a greater variety of paints and make them work successfully for you.

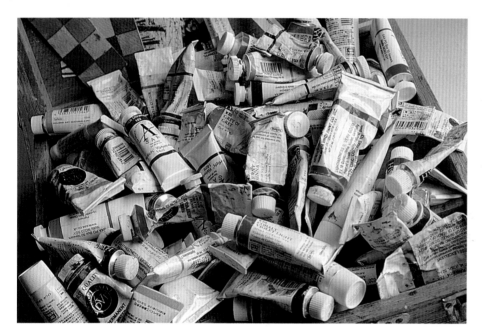

Not All Paints Are Created Equal
There are many types, colors and manufacturers of paint. As an artist it will benefit you to become familiar with the different properties of each paint you add to your palette. You should know which qualities apply to your paints. Are they transparent, opaque sedimentary, staining or nonstaining? You need to understand what each of these qualities means and how to take advantage of them.

Basically, pigments can be separated into the categories of opaque or transparent. Transparent pigments can further be divided into the subcategories of nonstaining and staining.

opaque sedimentary color

Heavy bodied paints, ones that block the passage of light, are referred to as *opaque*. These weighty pigments not only conceal the paper, but they cover any underlying layers of color as well. Glazes done with opaques may become heavy, but it is possible to glaze with them if they are greatly diluted with water. Once dry, opaques are difficult to remove, not because they have stained the paper, but because of their heavy weight. The large particles of an opaque pigment separate and settle into the pockets between the fibers of the paper. This is called *granulation* or *sedimentation*.

Paints that are opaque in quality are marvelous to use when depicting solid dense objects such as soil, tree trunks and rocks. Unfortunately, when over-mixed, they are often responsible for making the heavy, mudlike passages so undesirable in watercolors.

Glazing with Opaque Colors
Opaque pigments block out previous layers of paint. Notice that a light valued color, such as yellow, is capable of covering a hue of darker value. Multiple glazing with opaque pigments is not as successful as with transparent pigments. These glazes can create mud and less precise edges.

Dispersed Opaques
A quick rinse of a brushload of opaque paint will leave your water cloudy and block the passage of light. The label under the flask is obscured.

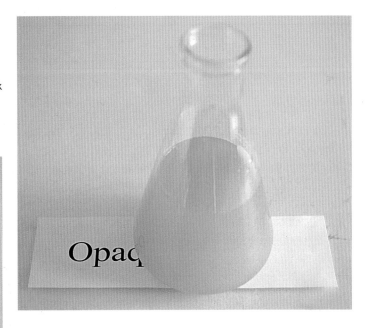

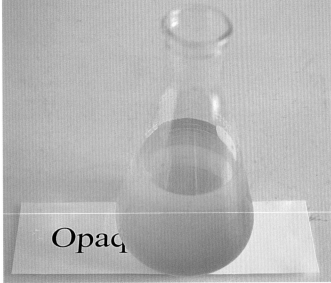

Sedimentary Colors—Settle Out
After resting undisturbed for several hours, the water is now clear. The heavy opaque particles have settled to the bottom of the flask.

The addition of a small amount of white, or any opaque color, to any transparent color will create an opaque.

transparent colors

Glowing, delicate glasslike colors that allow light to pass through the paint and reflect off the surface of the white paper to the viewer's eye are described as *transparent*. Pencil work and underlying hues remain visible even when glazed over with several layers of transparent color.

Transparent paints are the most effective for glazing. The multiple layers increase in value, change hue, or shift in intensity. They are also the best choice to suggest water and objects made of glass. Transparent color can be staining or nonstaining.

Nonstaining

Delicate pigments that can easily be removed from the surface of the paper are considered *nonstaining*. In taking advantage of the intrinsic qualities of the transparent nonstaining colors, you can create light airy passages or glasslike appearances on the paper. Areas painted with these pigments can be lifted to reintroduce light or make corrections.

Staining

Rich, potent colors that penetrate deep into the fibers of the paper, making them extremely difficult to remove, are classified as *staining* colors. When greatly diluted with water these pigments can be used for glazing, but because of their tinctorial power they will stain the paper and underlying layers of paint. Many paintings have been ruined by the overpowering, raw strength of staining colors. Transparent stains are essential, however, for producing handsome, intense darks.

Glazing With Transparent Colors
Transparent pigment glazes let underlying colors glow through. Imagine that you are painting with glass. The light passes through even when there are several layers of paint.

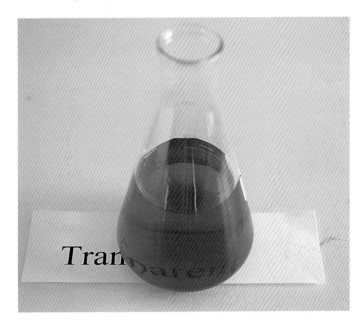

Dispersed Transparents
As the transparent color disperses, the water remains clear permitting the passage of light. There is little settling out as the fine particles remain suspended in the water. The caption on the label is plainly visible even after several hours.

Transparent colors work best when building multiple layers; you can build many layers without creating mud.

test 1: opacity and transparency

To determine which of your paints are opaque or transparent you can perform a simple test. It is important that you check all the paints in your palette because the attributes of colors vary between manufacturers. All colors with the same name do not possess the same qualities. Not only will these samples provide a valuable source of information, but they will serve as a good warm-up for painting.

supplies		
	Scrap piece of 140-lb. (300gsm) or heavier watercolor paper	Paints from your standard palette
	No. 8 or 10 round brush	HB or harder pencil
		Ruler or straightedge

1 PENCIL MARKS

With an HB or harder pencil, draw a series of uniform boxes in a row on the watercolor paper. Next to each box, write the color name of each of your pigments. Include the manufacturer if you use the same color from different sources. Applying even pressure, scribble a line through the boxes.

2 APPLY THE PAINT

Thin fresh pigment with a bit of water and paint it onto the dry watercolor paper in the boxes next to the appropriate color name. You will paint directly over the pencil marks. Repeat with each of the colors in your palette. Because even opaque paints may appear transparent when thinned, a second coat of each color may be required.

3 EVALUATE YOUR PIGMENTS

Once dry, thoroughly inspect your samples. The transparency of the paint will determine the degree to which the pencil shows. Paints that are more opaque will cover and obscure the pencil. Rate your paints on a scale from highly opaque to extremely transparent.

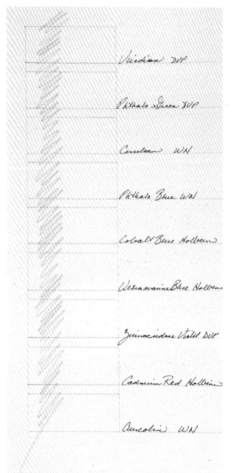

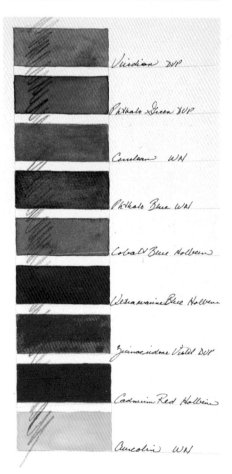

My Test Results

Opaque colors such as Cadmium Red, Ultramarine Blue and Cerulean Blue block and cover the pencil line. Just as the pencil line is concealed, so too will underlying layers of paint. The pencil lines show through Phthalo Blue, Phthalo Green, Quinacridone Violet, Viridian and Cobalt Blue. These colors are considered transparent.

test 2: lifting and staining

Although many transparent colors are easily lifted or removed with a bit of water and a soft brush, past experience may have shown you how difficult this task can be with some paints. Some colors simply refuse to budge. The reason is most likely the use of staining transparent pigments that seep into the paper fibers much like dye or ink. These stubborn villains are responsible for the demise of many a painting when an unsuspecting artist charges (adds pigment to an already wet surface) one of the culprits, such as Phthalo Blue or its powerful brother Phthalo Green, across the paper. Once applied, it is almost impossible to eliminate these intense stains. You can analyze the lifting and staining capabilities of your paints with the following test.

supplies	Your test strip from page 18	Strong bristle brush

Key Note

If a color is difficult to remove and conceals the pencil line, it is an opaque. Paints that allows the pencil line to show through are transparent. When a transparent is easily lifted it is referred to as nonstaining. Those that are difficult to lift are staining.

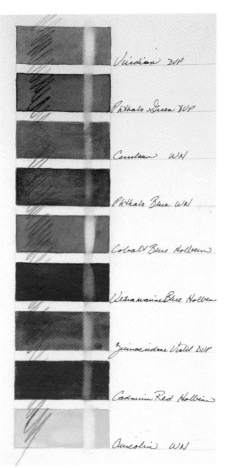

1 WET YOUR PIGMENT STRIP

Use the same test strip you created to determine the transparency and opacity of your colors. Brush a line of clear water through the dry paint swatches. Allow the water to penetrate for a moment. Make note of any colors that bleed when stroked with water, an indication that these are staining pigments.

2 SCRUB THE COLOR

Vigorously scrub with a damp brush to help dislodge the color. Blot with a dry tissue to remove color.

3 EVALUATE THE COLORS

The finished test strip now indicates which pigments on your palette are opaque or transparent as well as which of the transparent paints are staining and nonstaining. The nonstaining transparent pigments will be easily lifted revealing only the lightest tint of residual hue on the paper. Staining transparent color will have permanently penetrated into the paper.

My Test Results

Here are my test results with some notes on each color. Yours will vary according to the brands you select:

- **Viridian**—nonstaining transparent, removing color reveals the white paper.
- **Phthalo Green**—very staining, transparent, color does not lift well.
- **Cerulean Blue**—a heavy opaque, difficult to lift from the paper as the particles become lodged between the fibers.
- **Cobalt Blue**—nonstaining and transparent, lifts easily to reveal gleaming white paper.
- **Phthalo Blue**—staining, poor lifting of color is proof that this color penetrates into the fibers of the paper.
- **Ultramarine Blue**—semi-opaque, lifts poorly due to its sedimentary pigment.
- **Quinacridone Violet**—transparent, bleeding color and poor lifting denotes some staining, but not as much as the Phthalos.
- **Cadmium Red**—particles of color have settled into the paper, the heavy opaque pigment is difficult to remove, not because it has stained the paper, but because of its weight.
- **Aureolin**—a transparent, nonstaining yellow that lifts easily.

test 3: diffusion of staining pigments

Staining transparent pigments are the rich jewels of watercolor. Unfortunately, a few bad experiences with their strength and staying power can intimidate students and cause them to avoid using these exquisite, potent pigments. It would be most unfortunate to eliminate these powerful paints from your palette, for it is the staining pigments that provide deep, lush transparent darks. Stains are most attractive when used with very little dilution. In addition, a distinctive and exciting quality of staining pigments is their tendency to diffuse and blend together to create new color when re-wet. Few watercolor painters are aware of this characteristic, missing out on the subtle effects that can be achieved with it. The project, Use a Simple Template and Diffus-

supplies

Scrap of 140-lb. paper

No. 8 or 10 round brush

Paints from your standard palette

Ruler or straight edge

Basin of clear water

ing Color, *found in chapter 3 (page 38) makes use of this indirect effect. To determine which of your paints will bleed when re-wet and those that are more sedentary and passive, experiment with your pigments using the following test.*

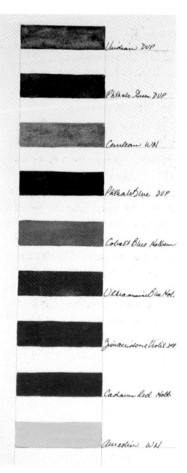

My Test Results

After your sample is dry, examine the results and note which paints stain and bleed. Your results may vary from mine as manufacturers may use different ingredients, even in paints with the same name.

- **Phthalo Green**—this fast moving stain diffuses quickly when re-wet.
- **Phthalo Blue**—the first color to bleed, this is a potent stain that moves very quickly.
- **Quinacridone Violet**—although slightly slower to start moving, this stain diffuses extremely well.
- **Viridian, Cobalt Blue and Raw Sienna**—these did not diffuse; previous tests indicate they are transparent nonstaining.
- **Cadmium Red, Ultramarine Blue and Cerulean Blue**—these did not bleed when re-wet as the heavy sedimentary particles in this opaque paint settle into the paper.

The diffusion of staining colors can cause frustration and grief when attempting to layer with stains. Staining paints work well when layering over another transparent. However, if you attempt to glaze over these potent stains, the color reactivates and permeates through any upper layers.

1 PAINT YOUR COLORS

On a narrow piece of watercolor paper, paint a fairly heavy stripe of each color. Use very little water with your paint, just enough to permit it to spread. Leave a broad strip of white paper between your samples. Allow the paint to dry completely. Label each color with its name and manufacturer.

2 WET YOUR TEST STRIP

Dip the test strip into a basin or sink of fresh water. Watch closely as the color begins to diffuse and move. Observe how some samples will bleed immediately while others will not. Keep the test paper in the water for only a few seconds after the color begins to move or too much will be washed away.

3 DRY THE TEST STRIP

Remove the test strip from the water and tip it to allow any bleeding of color to flow into the white spaces. Allow the colors to dry on a flat board.

If your color does not start to bleed within moments of soaking, you can encourage it to move by gently spraying it with water from a spray bottle.

a closer look at pigments

Why paints behave the way they do is easier to understand when viewed close-up. A microscopic depiction shows exactly what is happening on the surface of watercolor paper when pigment is applied. These samples of three different blues were magnified with a dissecting (low magnification) microscope. For this revealing project I enlisted the expertise of two of my art students, who by profession are a professor of biology and a pathologist.

All art on this page is photographed by John J. Heikkila, Ph.D.

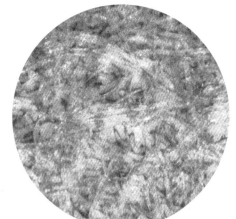

Cobalt Blue: Transparent Nonstaining

Cobalt Blue is a fine example of a transparent nonstaining pigment. The finely ground particles float on the surface of the paper. The paper fibers do not absorb any color, as is evident by the appearance of glistening white threads. The sample proved to be difficult to photograph because of the strong light reflected off the surface. It is reflected light that causes the transparent colors to sparkle in paintings.

Ultramarine Blue: Semi-opaque Sedimentary

Ultramarine Blue, a semi-opaque sedimentary paint, settles into the tiny pockets of the paper as well as coats some of the fibers. As the heavy particles are lodged within the spaces, it proves difficult to release these trapped granules later. As successive layers of opaques are added, the weighty particles create a dense, solid appearance that blocks light from traveling through to the surface of the paper.

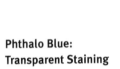

Phthalo Blue: Transparent Staining

Phthalo Blue is an extremely powerful transparent stain. The fibers of the watercolor paper absorb the dye-like color, and the paint travels along the length of the thread similar to the way water is drawn up by a plant stem. Paint that behaves in this manner is difficult to remove and is justly referred to as a stain. The pockets that form between the fibers remain white in comparison to the other two samples in which the pigment has settled into the depressions in the paper.

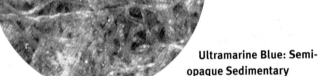

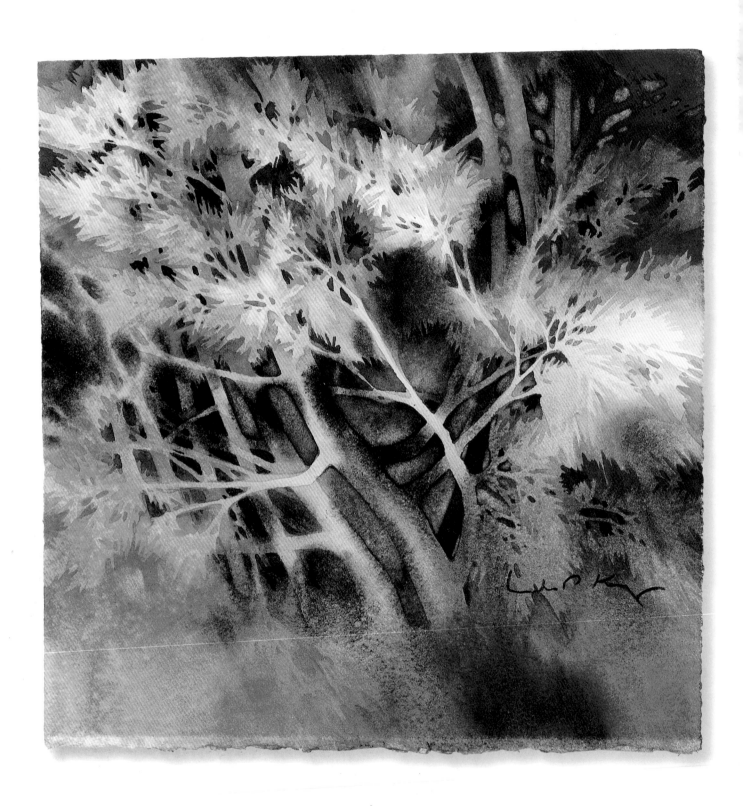

DID GENTLY KISS THE TREES
Watercolor
11" × 11" (28cm × 28cm)

underpaintings—
laying the groundwork

In organizing this book, I deliberated at great length about where to insert this chapter concerning the preparation of underpaintings. Much like solving the dilemma of "which comes first, the chicken or the egg," I needed to correlate lessons about underpaintings, design and shape building. Each is dependent on the others for successful results. Through my experience teaching workshops, I have found that students often find it hard to freely explore and experiment when worrying about rules and restrictions. It is, however, undeniable that when it comes to making art, a basic understanding of design is an asset.

Because I believe that we learn best what we enjoy the most, it is essential that having fun comes first and foremost. (Learning the whys and wheres will come later.) With this in mind, chapter two will focus primarily on the unplanned underpainting. If you are not already familiar with the pleasures of underpainting, let me introduce you to this wonderful device. An underpainting is the foundation or groundwork on which you will build your painting. These exciting beginnings are as personal and expressive as the individual who creates them and can be approached in a variety of ways, implementing a broad spectrum of techniques. Each method of applying paint will provide a unique appearance and will serve to stimulate creativity. You will learn the differences between them and when to incorporate each into your work.

Underpaintings can be created quickly, and are spontaneously unstructured making it possible to begin without needing to know where you are headed or what your finished painting will look like. This initial freedom allows you to break loose and apply paint freely to your paper without worrying about making mistakes. Alternatively, if you desire more structure, you can approach an underpainting with a fully developed plan, making careful decisions about design elements before you set your brush to work. The choice is up to you, but for your first attempts don't worry specifically about what you are going to paint. Much like brainstorming, just jump right in with reckless abandon. Soon you will see yourself making a gradual transition into a more innovative and focused work mode. With experience, the colors incorporated and the approach used will become more contemplative; the minutes will melt into hours.

Underpaintings are a great way to warm up to get your arm moving and the creative juices flowing. You might like to turn on your favorite music to set the mood. Don't hold back. Get your whole body moving.

If you prepare several underpaintings at a time you will be able to experiment freely. It is much easier to take a risk with something that doesn't have a remarkable value. Initially, it's more important to get color onto the paper and to overcome your white paper terror. As one piece is drying, prepare another, and then another. The spontaneous, unplanned underpaintings you create while working through this chapter can be used for the exercises found throughout the rest of this book. You will go through a lot of paper; however, don't consider it wasted. You may not be able to develop a particular idea from a particular underpainting at that moment, but sooner or later it will provide the perfect foundation for an idea you have in mind.

getting started with underpaintings

Almost all of my artwork begins with an underpainting of one type or another. Whether planned or unplanned, the options include wet-into-wet, wet-on-dry, dry-into-wet and experimental textures. Before you get started exploring each of these possibilities, I'd like to make a few suggestions to help make all of your underpaintings more successful.

Choosing Colors and Pigments

There are some decisions you need to make when selecting colors and pigments for your paintings.

Use a Limited Palette

To create color harmony, limit your working palette to three or four colors. The trick is to repeat these colors when developing the painting later.

Create Balance With Color

Although your first attempts are to be experimental and unplanned, you should consider the importance of balancing the design with color. If you use a particular color in one area, be sure to apply it in one or two other locations. Vary the size and shapes of the brushmarks or spatter the color to create repetition with variety.

Use Any Type of Pigment

From your tests in the first chapter you have established which of your paints are nonstaining or staining, transparent or opaque. Use any individual or combination of colors, but realize that there are limits to the number of layers you can build with staining and opaque paints.

What About the White Paper?

How much, if any, white you choose to leave is up to you. It's certainly easier to leave more white and cover it up later than to try to retrieve the pristine glow once it has been painted over. However, not all color schemes require white. Be bold! If the entire surface of the paper becomes flooded with exotic color, or turns to gray, you might be on to something wonderful.

Prepare Sensuous Color

You don't need to spend a lot of time deciding what color combination to use. Just choose any three or four tubes and squeeze the fresh paint onto your palette or other mixing surface. Don't be stingy. The following illustrations will show you how to prepare and apply your paint to produce evocative and inspiring color.

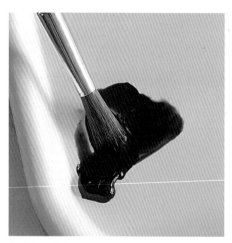

Exciting Color
Using fresh paint will encourage you to work in a faster, more spontaneous manner. Add only a brush load or two of water to the rich, luscious color. When working wet-into-wet there is already plenty of water on the paper. Think excitement and daring, not economy and restraint.

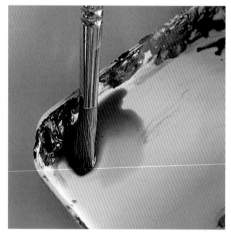

Anemic Color
Reconstituting dried nuggets of ancient paint will slow you down, and will usually result in weak, overdiluted color. This thin mixture is fine for layering and glazing on dry paper but not for underpainting.

Too Much Water, Too Much Mixing

This wimpy puddle of color is typical of what I often see on students' palettes. Dried paints have been revived and stirred together with too much water.

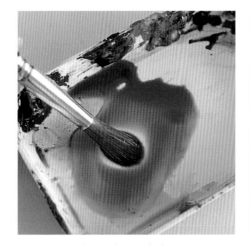

Blending Color

Combine fresh colors with just enough water to work the paint into a spreadable, juicy consistency. Don't overmix the colors in an attempt to make a homogeneous blend. Allow some of the original hues to remain unmodified. For example, when mixing violet, aim for one-third red, one-third violet and one-third blue.

Uninspiring Versus Passionate Color

Both of these samples were made with a combination of Ultramarine Blue and Quinacridone Violet dropped onto saturated paper. The lefthand portion illustrates the use of reconstituted, watery color that has been overblended. It has dried significantly paler than when applied, leaving only a bland tint of hues. The right side was painted using freshly squeezed color with little added water. It remains vibrant and exciting. There are a variety of dynamic and suggestive hues, as well as subtle blends, characteristic of applications of fresh, intense paints that have not been overmixed or overthinned.

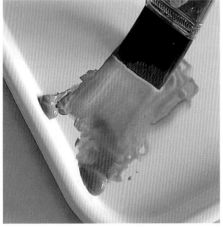

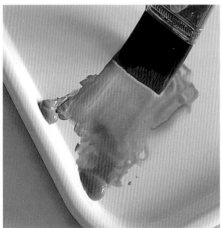

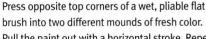

Double Dipping

Press opposite top corners of a wet, pliable flat brush into two different mounds of fresh color. Pull the paint out with a horizontal stroke. Repeat the stroke four or five times to work the color into the hairs of the brush while just slightly mixing the hues. On close examination of the brush and your palette, you should see a blend of color in the middle section bound by unmodified hues at the edges. Try this with a variety of brushes.

Subtle Blending

To achieve a more uniformly loaded brush, the same two colors, Raw Sienna and Cerulean Blue, are more thoroughly blended using a circular movement of the brush. Add very little water to the fresh paint, not making a puddle, and gently blend so each of the original hues still exists.

Let the Paint Work for You

Both of these samples were produced with two strokes of a brush loaded with Cerulean Blue and Raw Sienna on wet paper. On the left you see the results of the double dipping that allows the colors to blend, yet retain their individual identities. On the right there is a subtle separation and melting of the pigments, but the overall appearance has a more uniform glow. The natural qualities and separation of the combined pigments create delicate effects when applied to a wet surface.

wet mounting paper for wet-into-wet underpaintings

Colors that explode, mingle and flow, blurred lines, and soft gossamer edges are the hallmarks of a wet-into-wet underpainting. They are usually prepared rapidly and loosely. In fact, it is difficult to paint a tight wet-into-wet underpainting. Foundations produced in this way display the soft, suggestive lines, blossoming forms and organic shapes that are natural occurrences on a wet surface. They are especially well suited to the development of florals, still-life arrangements, close-ups of nature and ethereal landscapes.

supplies

Several pieces of various sized watercolor paper; 140-lb. (300gsm) is preferable, but 90-lb. (190gsm) will suffice	Plexiglas, larger than your paper	Fresh tubes of watercolor
	1½-inch (38mm) flat wash brush	Spray bottle filled with clean water
	Assortment of round brushes	Paper towels
		Plywood board for drying

1 WET BOTH SIDES OF THE PAPER

Stroke fresh water over the back of the watercolor paper with a 1½-inch (38mm) or other large soft flat brush, covering the entire surface. Flip your paper over onto a clean piece of Plexiglas. Brush your paper with clean water. Alternately, you may soak the paper in a basin of water, but applying the water by hand serves as a good warm up to actual painting and removes less of the paper's sizing, which is needed to retain crisp edges when building layers.

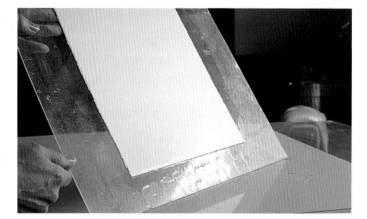

2 NO MORE STAPLES OR TAPE

The saturated paper will stick to the Plexiglas. Lift and tilt the Plexiglas to remove any excess water. With practice you will quickly discover how much water is needed. However, in the beginning too much is better than not enough. The surface must be shiny and the paper should lay perfectly flat. If you see any bumps, you have trapped an air bubble, or have a small dry spot on the underside. Simply peel up a corner of the paper and brush water across the back, then roll the paper down again.

3 WIPE UP EXCESS WATER

Mop up any extra water that has collected outside the edges of the paper with paper towels. Excess water left at the edges of the paper may cause undesirable backruns around the perimeter of your painting. Allow the paper to rest while you select and organize your paints.

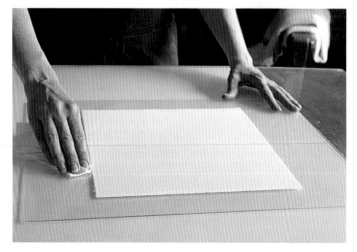

Deckle Edges

With no need to secure your paper with staples or tape, you can work all the way to the beautiful torn edges. When you frame your finished painting, show off this elegant deckle edge by float mounting.

tips for applying wet-into-wet color

The type of brush you use will determine the marks created. Give several different brushes a good workout. Practice a variety of brushstrokes, such as short quick jabs and long sweeping caresses. This underpainting will be used in chapter five for the project *Painting the Flavor of Berries, Cherries and Grapes* (page 76).

Freely paint beyond the outer edges of the paper. Make your brushstrokes extend past the boundaries.

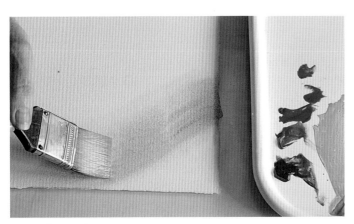

Use a Flat Brush
A soft, flat brush is great for covering large areas with color and cutting around shapes. Hold the brush at various angles and use broad gestural arm movements to create flat strokes or thin edges. Allow the paint and wet paper to work together. The wetter the paper the faster your paint will move and diffuse across the paper. The paper should still be visibly shiny at this stage.

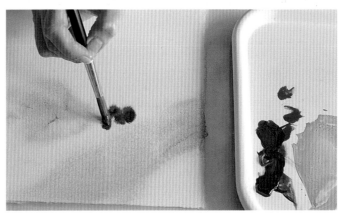

Drop in Glorious Color
Double dip a wet, round brush into fresh paint and touch it to the surface of the saturated paper. Take time to watch how the paint flows off the tip of the brush.

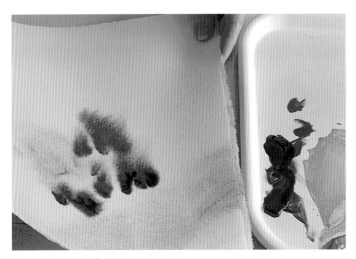

Make the Color Flow
Lift and tilt the paper to encourage the movement of color. Some pigments naturally move and spread quickly; others are more sluggish. With practice, you will be able to predict the results, thereby gaining some control.

Use the backs of discarded, unsuccessful paintings to practice wet-into-wet underpainting techniques.

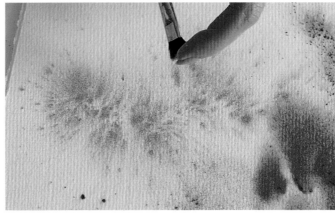

Spatter and Splatter
To spatter paint, simply flick the bristles of a stiff brush or toothbrush that has been dipped into wet paint. Spattering paint in this manner creates a fine dusting of color. To prevent your fingernails from filling with paint, use a small stick to flick the bristles. It's OK to get messy, but make sure you have a good nail brush on hand when you finish your underpainting. A number of paints contain harmful ingredients that can be ingested through the skin.

Splattering has a loose, free appearance and helps in unifying your work. The speckled appearance also serves as a gentle transition between two areas of different colors. A brush load of paint quickly tapped against the stationary fingers of your other hand will splatter color across the damp surface. For more control, hold the brush close to the surface of the painting.

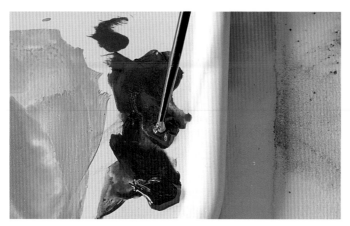

Drawing With Paint

Look closely and you will see that I am double dipping with the wrong end of the brush. A sharp pointed stick, toothpick, or the end of your brush can make beautiful calligraphic marks on both wet and dry paper. Thick, fresh pigment is necessary. Simply dip your drawing tool into heavy paint and scribe onto the wet surface. If it appears that you have a blob of paint on the end of a stick, you're doing it right.

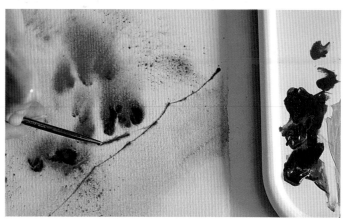

The Brush Is an Extension of Your Whole Self

To encourage a freer movement when drawing with color, hold the brush upright, high on the handle and paint with your full arm and shoulder, rather than just the fingertips. Push the brush away from you and hesitate momentarily or change direction to make beautiful lines that can be strong or delicate and in a variety in colors.

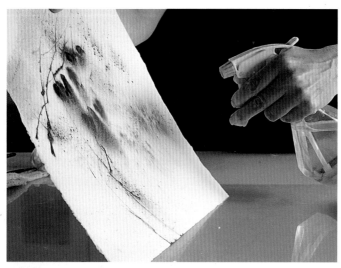

Make Colors Travel With a Spray of Water

To speed the flow of paint, spray it with water. By lifting the loose paper you can roll and tilt the paper to encourage the movement of color. A spray of water can also be used to soften areas that are too dark or intense or to remove unwanted color. Allow the colors to mingle together to create interesting transitions and new color.

Dry Your Paintings on a Wooden Board

When you are satisfied with the results, gently lift the wet underpainting from the Plexiglas, and transfer it to a flat wooden board to dry. Paintings left on the Plexiglas may stick. They also dry very slowly. Furthermore, because the paper will dry from the outside edges in, it will draw water from the Plexiglas causing backruns around the edges.

Consider the overall composition and movement, as well as the balance of colors, textures, and shapes in your underpainting. Have you isolated the design in the middle of the paper? If so expand it to the edges. Use the whole paper. Continue to brush, spatter, and splatter paint until you are satisfied with the results.

dry-into-wet underpainting

Colors that softly fuse yet retain their original identities, crisp and descriptive lines which soften to a whisper, and edges that range from highly descriptive to illusive are indicative of the dry-into-wet underpainting. The paint isn't really dry, but is fresh, with little or no water added. This unique process provides for a most unusual union of freedom and control. Foundations prepared using this approach can display softly diffused layers of textured bands, ideal for imaginative, romantic landscapes.

Prepare the paper as for a wet-into-wet underpainting, by brushing both sides with clean water and laying it onto a piece of Plexiglas.

Your first few attempts at this type of underpainting may prove to be a bit frustrating as you pound the surface off the paper or stir up piles of mud, but don't give up. The results are well worth the effort. Remember to use quality paper and a

supplies

140-lb. (300gsm) watercolor paper

Plexiglas, larger than your paper

1½-inch (38mm) flat wash brush

Fresh tubes of watercolor

Spray bottle filled with clean water

Paper towels

Plywood board for drying

An assortment of stiff bristle brushes. The bristles need to feel coarse but flexible, not soft or floppy. Try an oil painting brush, a badger hair shellac brush, or cut the bristles of a cheap house-painting brush down to about 1-inch (25mm).

stiff brush, and add only a drop or two of water when the paint refuses to move and blend.

You will be able to use this type of underpainting for developing a landscape as demonstrated in the chapter seven demonstration, Finding Solace—The Great Escape *(page 117)*.

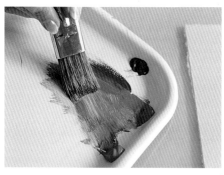

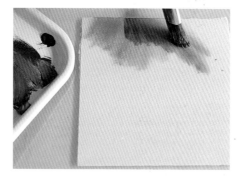

1 PLUNGE IN
Plunge a dry bristle brush into fresh gooey paint. Take the same brush and plunge into a different color. Stroke the brush repeatedly on the palette to load and work the paint into the bristles. You most likely will not need to add extra water. The brush should leave a scratchy dry-brush texture on the mixing surface.

2 MAKE STACCATO STROKES
Apply the paint to the wet paper with aggressive downward, chopping strokes. Work the short, brisk brushstrokes across the width of the paper, pausing occasionally to reload with a new combination of colors.

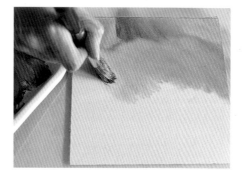

3 APPLY A SECOND LAYER
Gently pound a second layer of color across the surface. Include changes in the angle of the strokes. As you pull the brushstroke down you will also drag surface water onto the previous layer. The combination of drybrush texture and the moisture of the paper will produce gorgeous bands of organic swells, great for suggesting blowing grasses, shrubs or waves.

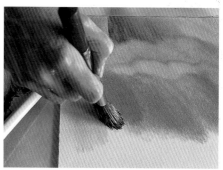

4 ADD MOISTURE TO YOUR PAINTING
As the paper begins to dry you may need to add a little moisture to the brush. Too much water will turn your dry-into-wet underpainting into mush, so barely touch a corner of the brush into the water. Continue to build the bands of color across and up the surface of the paper. Dry the finished underpainting on a wooden board.

wet-on-dry underpainting

For unadulterated color, crisp, hard lines and sharp, precise edges, a wet-on-dry underpainting will offer you the power of control. A foundation prepared using this method will certainly leave very little up to the whims of the medium—the paint won't go where you don't put it. The firm descriptive edges and geometric shapes that appear on the dry paper are well suited for suggesting buildings and other man-made structures, stylized florals or the dynamic movement of birds in flight or wind-whipped sails.

For this type of underpainting you will not need to pre-wet the paper. Simply begin on unstretched, dry watercolor paper. You won't need to fasten the paper down.

supplies

140-lb. (300gsm) watercolor paper

An assortment of soft, flat and round brushes

Variety of fresh tubes of watercolor paint

Spray bottle filled with clean water

Paper towels

Plywood board

Underpaintings With Experimental Textures

There seems to be no end to the creativity and imagination that artists have when it comes to applying unusual, experimental treatments to their paintings. Most every conceivable kitchen gadget seems to have found its way into the studio, and fanciful devices have been invented for pouring and spattering an assortment of paints and inks. Freezing, sprinkling charcoal and salts or pressing plastic film, leaves and cheesecloth onto the paper's painted surface all leave interesting marks. You will find many novel suggestions in instructional books dedicated specifically to experimental phenomena when working with mixed water media. It's great fun to try these wild, innovative techniques and products, and the results can be stunning. However, surface treatments such as these should be considered only as a point of departure. Any technique that takes over the painting or, in fact, becomes the painting, may be viewed as a gimmick. I'd like to encourage you to take your artwork beyond any dependency on maneuvers and tricks. Go ahead and pour, sift and stir to awaken and stimulate your creative mind, and then investigate the possibilities of how far and where it will lead you.

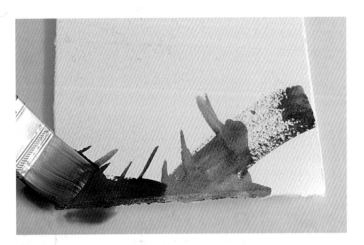

1 SWING YOUR BRUSH
Double dip a 1½-inch (38mm) flat brush in juicy paint. More water is needed in this mixture to allow movement on the dry paper. Work over the surface with swinging brushstrokes that extend beyond the constraints of the paper.

2 GO FOR EXCITEMENT
Spatter and splash the paint. Hold the paper vertically to create trickles and color runs. Dash a handful of water across the surface to soften edges. Continue to add color with a variety of brushes until a pleasing design emerges. Dry the completed foundation on a piece of plywood. Because this type of underpainting has not been uniformly saturated with water, it may dry with a few wrinkles or bumps. These will not interfere with further developing the painting.

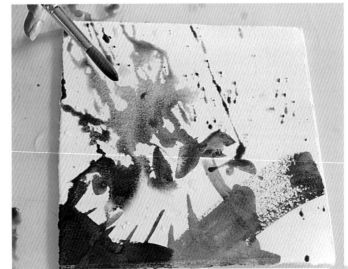

Always take into consideration any damage that added products might cause. If salts and acids will eat through concrete, they certainly won't be kind to paints or paper.

heavy on damp—advanced technique

The process of working on damp paper using progressively dryer paint affords building multitiered layers while eliminating the need for drying between the layers when painting florals and close-ups of nature. You will want to try this more advanced approach to building underpaintings again when you have a firm understanding of developing layers (see chapters four and five). You will need to be a confident shape carver with a plan in mind to take full advantage of this timesaving and extraordinarily beautiful type of foundation. For now, practice making a few layers on scrap paper.

supplies

140-lb. (300gsm) watercolor paper

An assortment of flat brushes

Freshly squeezed tube paint

Spray bottle filled with clean water

Plywood board

Paper towels

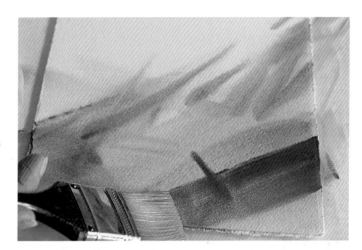

1 BEGIN WORKING ON DAMP PAPER
Begin with a wet-into-wet underpainting by brushing on strokes of exciting color. When the shine has left the surface of the paper you can begin to build layers and create shapes that will hold their form. Load a soft 1½-inch (38mm) flat brush with heavy paint to which little or no water has been added. Using the flat side of the brush begin to carve around a shape. Pull the color out to the edge of the paper. The new layer of paint should hold its shape, yet the edges should soften slightly.

2 ADD MORE COLOR
While the paper and paint are still damp, load the brush again with thick paint of an increasingly darker value, different hue or intensity. Allow a slim margin of the last layer to remain, and pile on another layer. Because there is very little water both on the paper and in the paint, the color will not run or cause backruns and remains well controlled. Notice that I have painted beyond the edges of the paper. Transfer the damp paper to a piece of plywood to dry. You will see this technique put to use in the demonstrations *Layering Floral Shapes: Painting the Spirit of Joy* (page 106) and *Lifting and Tinting: Swept Away* (page 111).

Design Tip

For best results when preparing underpaintings, use a predominant type of brush movement for the entire foundation. Choose from either curvilinear, diagonal, horizontal, vertical—or any combination. In this sample I have worked primarily with diagonal brushstrokes. This restraint will aid in later shape designing, reduce confusion and help you interpret your underpaintings for future development.

Planning Underpaintings

The preparation of a planned underpainting differs only in that the decisions made regarding the placement of colors and forms depend on a predetermined outline. At this time, you will want the most glorious color, intriguing textures and strongest contrasts arranged in a satisfying, well-balanced manner because they will naturally serve as areas of interest. You will find information regarding design options in chapter six, *Picture Planning Made Easy* (page 84). The formation of controlled shapes and multiple layers in a planned underpainting are made possible by working with heavy paint on damp paper.

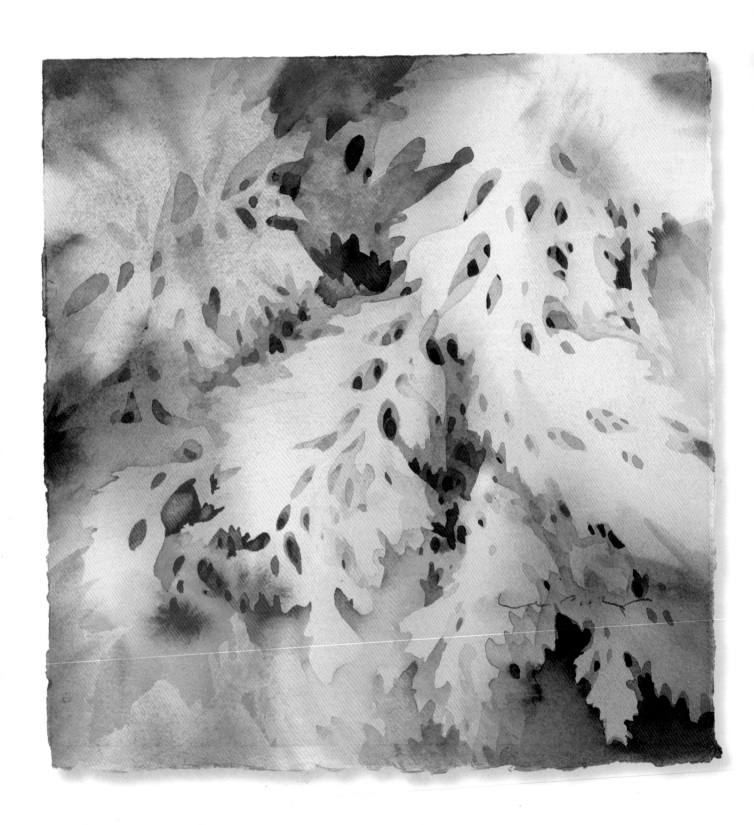

A Dream Within a Dream — Begonia and Dusty Miller
Watercolor
11" × 11" (28cm × 28cm)

getting
into shapes

I am a shape maker. You can become one too. In doing so, you will simplify and greatly improve your artwork. By designing with shapes, instead of attempting to recreate things, you can produce creative and original artworks and make the experience of painting more rewarding and satisfying. Even if your personal style includes making fine details, elaborate embellishments or a highly decorated surface, take care of the shapes first.

Learning to see and work with shapes is easy and fun. It is essential to first understand that in painting we are merely putting paint to paper. No matter how expertly the paint is applied, it is impossible to actually make a tree, flower or rock. It is not in our power. However, we can paint or draw a symbol or shape that will represent these things. By creating distinctive shapes, the painter can suggest a tree, leaves, rocks, stones or any other choice of subject.

In this chapter you will learn how to see simple shapes, both positive and negative, and how to build paintings with them. It has been my experience that in order to make the cognitive and visual shift required to learn to paint in the negative, most students need to fully immerse themselves in this alternative process and way of thinking. Temporarily abandon your customary approach to painting and follow along, step by step, with the exercises. Once you are able to competently work with this alternative approach, you can decide how much negative work you wish to incorporate into your personal form of expression.

seeing shapes

A painting is a two dimensional piece of art. It is designed by assembling a collection of shapes and fitting them together like pieces of a puzzle. The parts need to relate to one another and serve to lead the viewer through the artwork. A shape is an enclosed form that has width and height and can be classified as round, square, triangular or some modification and combination of these categories.

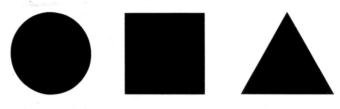

Basic Shapes
Circles, squares and equilateral triangles are the basic shapes.

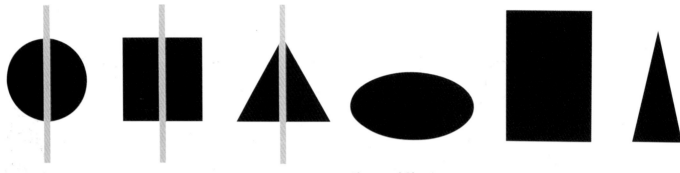

Perfect Symmetry
These basic shapes are perfectly symmetrical. It is this perfect balance that makes them static and monotonous. Visually, they are just not very interesting.

Elongated Shapes
To make a shape more interesting, make it longer in one direction, varying the width or height.

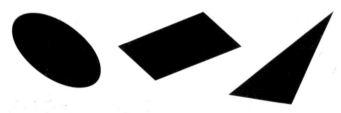

Dynamic Shapes
Positioning your shape on an oblique angle suggests movement and makes a more dynamic statement.

Distinctive Shapes
To make a shape more informative, requires a descriptive silhouette that reveals the character, mass or function of the shape. Variety in the edges — soft, hard, rough or smooth — gives the viewer additional information and makes your shape more interesting. Notice that I have simply trimmed away at the edges of the circle, square and triangle to create these distinctive shapes.

Squish, stretch, rotate and sculpt to transform boring shapes into entertaining and descriptive symbols.

34

creating a motif from nature

When creating a painting, it's easy to get sidetracked by all the confusing information and intricate details, especially when you are working in the great outdoors. There is just so much to see, and in the excitement sometimes we attempt to capture all this wonderful inspiration in one picture. It's little wonder that the artwork can become overly complicated and lose focus. When you find yourself in this situation, try looking for the simple shapes first. To help you see just what I mean, closely examine these images. Concentrate on a small area and try to ignore all the nonessential details. See each object as a single shape. Next, explore the whole photograph. Search for shapes that are similar. Notice how a single shape is frequently repeated in nature. Each plant has its own unique shape and we commonly identify the type of plant by the shape of its leaves, flowers and stems.

As you investigate the paintings in this book, you will discover that I have introduced only a limited number of shapes in each piece. The paintings are then designed and built with repetitions of those few shapes. Variation with repetition keeps them from becoming boring.

Shapes Are Everywhere

Plants are not the only place where we find repeating simple shapes. You will find them everywhere in nature and in manmade structures as well. Repeating shapes need not be identical, only similar. Variety in placement, color, size, texture and direction create interest and movement, and can suggest growth. Colors change with the progression of the seasons. The wind, sun and insects affect the perfect shapes and create more captivating appearances. Take time to examine the simple and complex shapes you see daily.

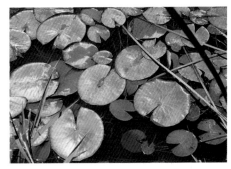
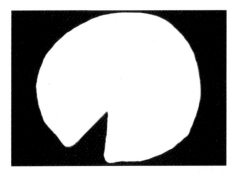

Identifying Shapes

In this photo of lily pads, the simple, flat, circular shape of the leaf against the dark water is easy to see. The triangular slit at the edge helps us identify the shape as a lily pad. They are different sizes; some have tattered edges. Notice how the pads shift in direction. There is also variety in the shape and sizes of the spaces between the pads.

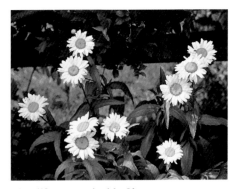
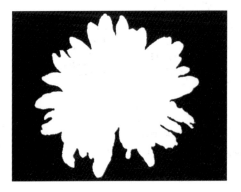

Simplify Recognizable Shapes

The daisy's petals create an unmistakable, distinctive silhouette. Upon closer examination, you will notice that each daisy is unique with subtle differences, yet maintains the characteristic, round daisy shape. It is not necessary to paint in veins, dew drops, or ladybugs. Even without the yellow center, this shape and its serrated edge reads as a daisy.

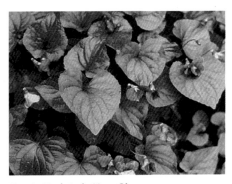
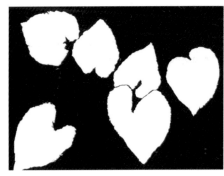

Create Variety in Your Shapes

The violet leaves curl and overlap. There is variety in size and direction in these numerous heart-shaped leaves.

Find a shape and repeat it.

CARDIFF
CAERDYDD

visualizing in the negative

When a sculptor creates a figure with clay, he may begin by forming the torso. He then attaches additional clay that has been shaped into legs, arms, hands, feet, neck and head. This is an additive process; something is added to another. Conversely, the sculptor may choose to carve a figure from a block of clay or marble by chiseling and gouging, reducing the excess raw material and exposing the figure within. This is a subtractive approach; the form is liberated by removing something.

Watercolors, acrylics, oils, and many other mediums can be tackled by using either of these two strategies. Typically we paint one shape on top of another, employing the additive approach. For example, you might begin by painting a field, then add the trunk of a tree, followed by attaching branches and leaves. Additional elements such as a building, grasses, a fence or perhaps a figure are added to the scene. If on the other hand you carve out your shapes, paring them down, you are taking a subtractive approach; constructing in the negative.

You can still create trees, buildings, grass, and figures, essentially any subject you choose, using the subtractive approach. The difference is that in a subtractive approach the shape is created by painting around the object rather than painting the object itself. By glazing over the negative space, you will carve around shapes to bring the desired form forward. You can paint landscapes, florals, figures and still lifes with the subtractive, or negative, process. Subtractive/negative is the approach you will be exploring throughout the remaining projects in this book.

Exercising Your Artistic Eye

It isn't difficult to learn how to make the visual shift from positive to negative and expand the way you see. Exercising your visualizing skills takes only a few moments a day. Select an object, a branch of leaves for example. Examine the main limb, the attached bough, stems and leaves. Now consider how you could draw the branch without drawing these "things". Think shapes. Become aware of the space that surrounds the branch and the leaves. Search for the captured negative spaces between the leaves and the stems and the spaces around the branches. These are the shapes that you will use to create the branch of leaves using the negative, or reverse, approach.

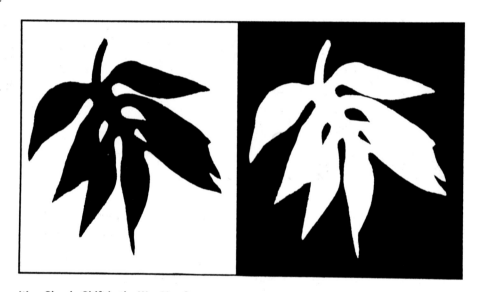

It's a Simple Shift in the Way You See
Look first at the simple positive shape. Now concentrate on the space around the shape. Next look for the spaces captured within the shape itself. Shift your perception from the positive to the negative.

The negative space *is* a shape.

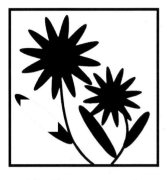 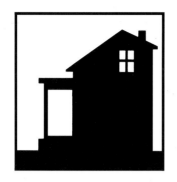 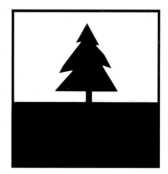 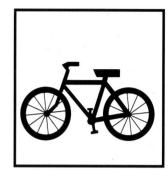

Positive Shapes

The positive shapes are shown in black. We recognize these unsophisticated symbols as flowers, a house, a coniferous tree and a bicycle. This is the way most people typically create images. The outline is drawn and then the shape is filled in with color, or in this case, black. The correlation between an object or shape to the background field against which it is seen is referred to as the figure-ground relationship. The figure is the positive element; the background is the negative. Generally the positive appears to be in front—it advances—and the negative, in the back—recedes.

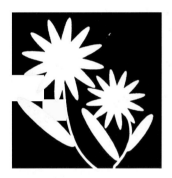 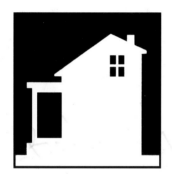 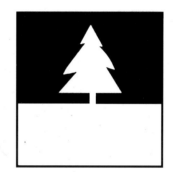 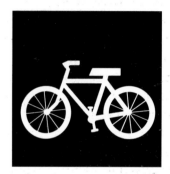

Negative Shapes

Here the identical subjects are depicted using the negative space. The same outline is used to define the edges, but color is applied around the shape. It's a simple shift in the way you see. In this set of illustrations, the negative space is shown in black. Once again, you recognize flowers, a house, a coniferous tree, and a bicycle. Concentrate on the black shapes around and within the objects, rather than on the object itself. Simply defined, negative space is the space around and between an object. In a painting, the space is contained within the boundaries of the paper or canvas. The resulting shapes that occur between the positive objects and the edges of the paper have size, direction, and dimension (height and width) and are referred to as negative shapes. The small spaces trapped between larger positive shapes are the captured negative shapes as seen, for example, as the window and porch of the house and the shapes between the spokes of the bicycle's wheels. Perceive the space as a shape.

Working Together

Both positive and negative shapes are required to complete the whole. The negative space and the positive shapes share the same edges. If you have drawn one, you have drawn the other. One does not exist without the other.

Make a Visual Shift

Take some time daily to look for interesting shapes that silhouette other subjects. Look first for the simple positive shape then concentrate on the space around the shape and captured within the shape itself. With practice it will become easier to make this visual shift.

use a simple template and diffusing color

In this fundamental project you will practice applying paint to create a negative shape. You will be using a simple paper template for a pattern and staining pigments that diffuse when re-wet. Read through the entire procedure first to completely understand the process and what it is that you are trying to achieve. You will need to keep an open mind as you work, understanding that the final painting will take on a life of its own. The end results may be a little unpredictable depending on what type of paints you choose and the re-wetting process. Crisp edges will soften. Colors will blend, lose some intensity, and whites will most likely disappear. Take the risk.

supplies

Pigment test samples from pages 18 and 20	Phthalo Blue (or Winsor Blue)	Pencil or watercolor pencil
A 6" x 6" (15cm x 15cm) piece of watercolor paper, 140-lb. (300gsm) or heavier	Quinacridone Violet (or Permanent Rose)	Handheld hair dryer
	Ruler or straightedge	Paper towels
No. 8 or 10 round brush	Tracing or overlay paper	Basin of clean water
		Plexiglas
	Scissors	Tracing paper
	Sketches	Spray bottle with clean water

1 MAKE YOUR TEMPLATE

Create a fresh contour drawing of an object or figure, or scan through your sketchbooks to find a simple drawing. Flat, descriptive shapes with little or no interior details work best. Draw the outline of your sketch onto tracing paper and then cut it out. Be sure that your image is smaller than 5" x 5" (13cm x 13cm).

2 TRACE YOUR TEMPLATE

Embellish the edges of your painting with a simple checkerboard. On a piece of 6" x 6" (15cm x 15cm) watercolor paper, carefully measure and mark off the pattern in $^3/_4$-inch (19mm) squares. Random or organized border patterns, such as this, enhance the surface and enrich the visual stimulation. Borders are fun to design and paint, and can be as simple or as fanciful as you choose.

Position your paper template on the watercolor paper and trace around it with a graphite or watercolor pencil. Because you are tracing around your template, your image will be slightly larger than your original drawing.

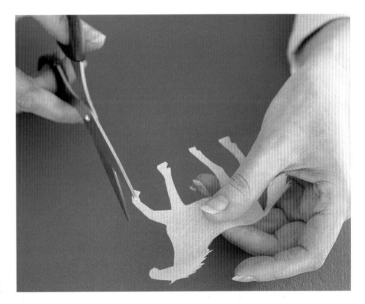

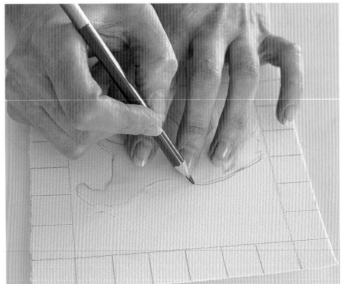

We are working toward strength and control at this point in the development of the painting.

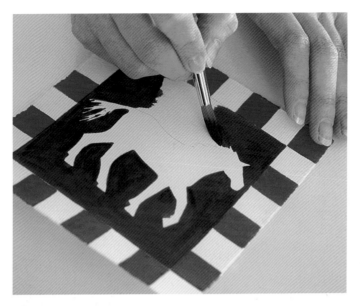

3 APPLY THE PAINT

Your choice of pigments for this project must be quite specific. You will need to use some staining pigments, as they will diffuse when re-wet in the final step of this exercise. Squeeze fresh paint onto your palette. Phthalo Blue (or Winsor Blue) and Quinacridone Violet (or Permanent Rose) are good choices. Load your brush with fresh Phthalo Blue and apply it around the shape with bold, direct strokes. This is the negative space. The white paper is left as the positive shape. Use only as much water as required to spread the paint. Streaks and overlapping marks are acceptable. Stains tend to decrease in value and strength if applied thinly so using too much water and reconstituted dried nuggets of paint will produce weak, wishy-washy results.

Use thick, bold strokes to paint the squares in the border using Quinacridone Violet.

4 DRY THE PAINTING

My horse appears, not because one has been painted, but because the negative space around it has been filled with color. If your shape needs adjustments, trim it down by carving into it with more paint. When you have finished painting the negative space around your shape, the painting must dry completely. Use a handheld hair dryer to speed the process or let the painting air dry.

If applying heavy staining pigment directly to your paper intimidates you, rest assured this is just what this job requires. Light tints and delicate washes just won't work this time.

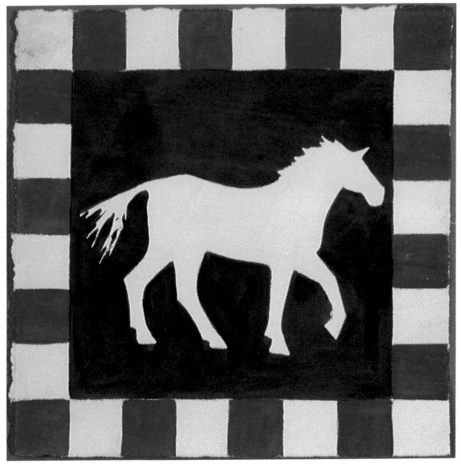

5 RE-WET THE PAINTING

Now comes the exciting part of this project. Have some paper towels near by. Submerge the painting into a basin of clean water. The paint should start to bleed immediately. Don't panic. This is what you want to happen. Once the color begins to diffuse, remove the soaked paper and place it on a piece of Plexiglas. Any further re-wetting of the painting at this time with a brush or sponge will cause the paint to lift and smudge.

6 DIRECT THE COLOR FLOW

The white of the paper may have disappeared as the staining colors dispersed across the paper. Lift and tilt the paper to direct the flow of color. If too much color flows into an area, wash it away with a misting of water from the spray bottle. Excess water can be poured off the painting into the basin.

Tips

- Keep any templates you make in an envelope to use for future projects.
- If your paint doesn't run, let it soak for a few moments longer, or use a soft misting of water from a spray bottle.

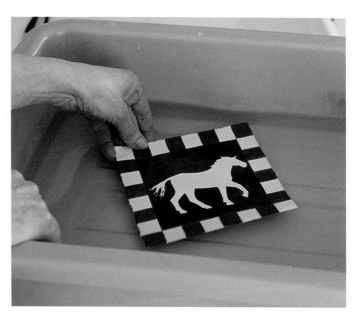

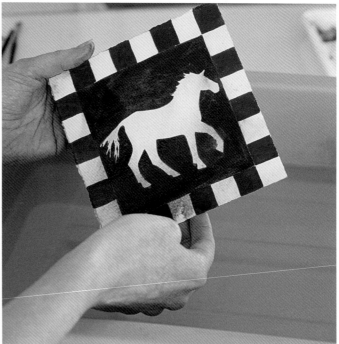

Relax

You may be tempted to grab for the paper towels to mop up the excess water, but try not to worry about it right now. You have more important things to do. Sometimes creativity can be messy.

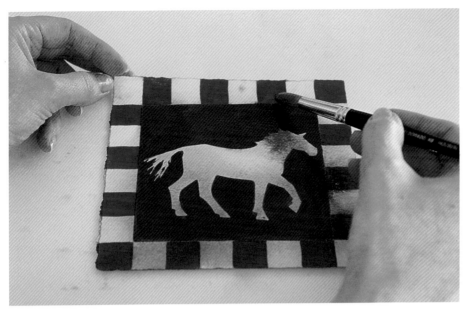

7 ADD DETAILS

If too much color has washed off, simply drop in some more pigment with a loaded brush. If desired, additional details can be added with watercolor pencils. When applying them directly to the wet paper you will achieve soft, blurred marks. Remember, however, these cannot be removed.

Your painting is now in a delicate state. Don't overwork the surface at this stage of the painting. Try to touch it as little as possible as even a fingertip will disturb the paint. Don't stroke the surface with a brush or you'll leave nasty streaks.

When you are satisfied with the appearance, lay the painting on a piece of plywood board to dry. Now you can clean up your mess.

A Luminous Watercolor

Because the pigments have flowed and diffused together, this watercolor has a soft luminous quality to it. Edges appear less crisp and the white of the paper has disappeared. I like the soft, gently worn surface. It has the look of faded denim jeans.

Mix and Match

You can frame an assemblage of multiple squares together much like a patchwork quilt.

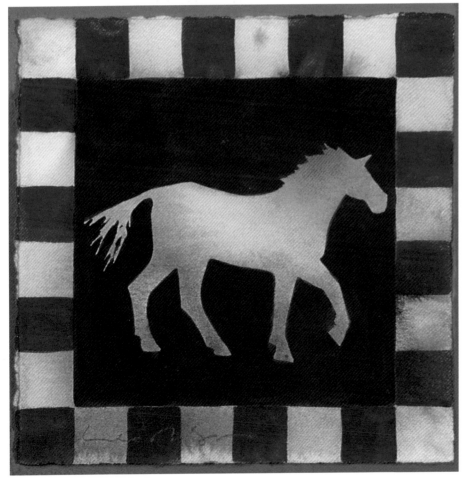

QUILT SQUARE
6" × 6" (15cm × 15cm)

surround your shapes with glorious color

You may have discovered that watercolor sometimes seems to have a mind of it's own. When developing a painting in the negative, you will want to take advantage of the unique qualities of this fascinating medium to surround your shapes with beautiful, exciting color. You'll need to practice painting the negative space of simple and complex shapes in order to master the skills needed to effectively maintain control while allowing this unpredictable medium the necessary freedom to weave its magic.

Tips

When working in the negative, continually remind yourself that you are not painting an object, for instance a leaf, rather, you are painting the space around the leaf.

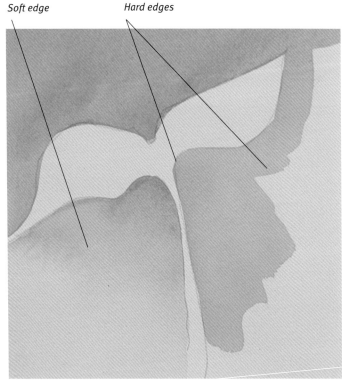

Soft edge *Hard edges*

Working With Flat Color
In the previous project, you painted the negative space with an even, homogenous application of one color. This method of applying paint in a single, smooth coat creates a flat, even layer of color. The negative space and the positive shapes share edges. Descriptive edges attract the viewer's attention and can effectively suggest form and texture.

Creating Hard and Soft Edges
Hard edges are created when the paint is applied to dry paper. This direct method of application is easily controlled. A hard edge will denote the border of a new shape. *Soft edges* appear when moist or wet color is applied to damp or wet paper. Color can be premixed on your palette or mixed directly on the watercolor paper. Using this wet-into-wet technique and dropping different hues onto your painting creates subtle and fascinating transitions in color. The resulting beautiful effects are the trademark of watercolor and are difficult to achieve with any other medium.

creating soft and hard edges

Practice painting around your shapes using both of these methods. There will be times when you want soft edges—your color soft and delicate, gradually fading away into white paper. You can do this by painting onto wet paper. At other times you will need to employ a more direct application to create a bold solid appearance or to maintain control—hard edges. Paint applied directly to dry paper does not spread and will create a hard edge along your shape. This is great when you need control.

Remember, soft, flowing edges occur on damp or wet paper. Hard, crisp edges are created on dry paper

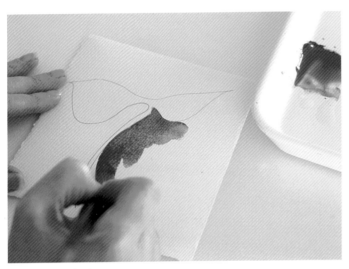

Creating Hard Edges
Squeeze a dime-sized amount of fresh paint onto your palette. Fill a no 8, 10 or 12 round brush with water and blend into the paint. Continue adding water and mixing until you have a smooth, medium-bodied mixture. Mix a quantity of paint larger than you think is required; there won't be time to stop to make a new batch of color once you start painting. Press the brush against the side of the palette to remove excess paint that may drip. Place the tip of your fully loaded brush at the outer edge of your shape and drag the paint immediately outward, toward the edge of your paper. You will need to work quickly to avoid streaks caused by disturbing paint that has started to dry. With practice you will develop confidence and a steady hand.

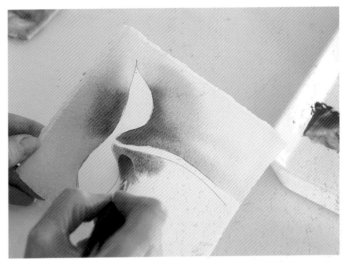

Creating Soft Edges
To produce the soft edges that make watercolor so appealing, first dampen your paper with water in the section you wish to fill with color. Areas left dry will remain white. Now touch the wet surface with a brush load of juicy color. The color will flow from the brush and disperse across the moist surface. You may drop in the paint slightly away from the edge of your dry shape, as it will naturally gravitate toward the shape. By lifting and tilting your damp paper, you can encourage the paint to move rapidly.

graded washes

Repeat these exercises on a large piece of watercolor paper using a variety of shapes. Experiment with different colors. Try various methods of applying the water and paint mixtures to the paper. You might flick, spatter, or drizzle water or paint using a variety of brush types.

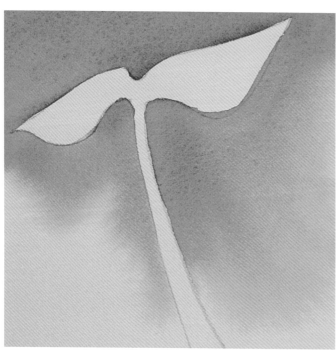

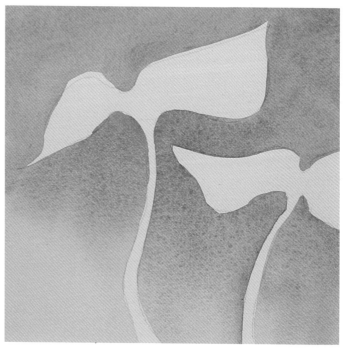

Single Color Graded Wash

Using a large soft brush, dampen with water exactly the area to be painted. Drop fresh, juicy color onto the moist surface. For your first effort, use just one color. Burnt Sienna has been used in this sample. Tip and tilt your paper to allow the paint to flow. Water is the vehicle that speeds the paint across the paper. The ratio of paint to water is variable; there is no absolute. Too much water and the color will become diluted and weak; too little water and the paint will not flow. With repeated practice you will be able to determine the right balance of paint and water that works for you. Do not go back into an area once it has started to dry. This will cause undesirable backruns.

Mixed Color Graded Wash

Combine, but don't over mix, two colors together on your palette. In this illustration Raw Sienna has been added to Cerulean Blue. Using a large soft brush, surround your shapes with water. This is the negative space. Dampen all areas except inside the shapes; these are to remain white. Touch the tip of a well-loaded brush onto the damp paper. The color will flow from the brush and spread across the moist paper to create soft edges. Hard, precise edges will form along the dry perimeter that delineates your shape. Continue to drop in additional color. With a soft, wet brush, drag the color out to the (outside) edges of the paper and up to the other shapes. Add water as required to allow for flow and to soften some of your edges. Tilting or gently rolling your paper will encourage the paints to interact and separate.

Once your shapes have been surrounded with color, allow the painting to dry. Once again, do not go back into paint that has started to dry or you will create a backrun or disturb any natural granulation that may develop during the drying process.

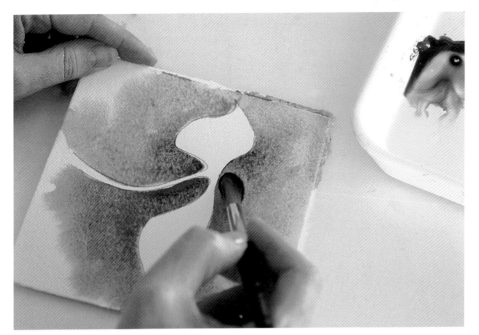

Tips

- If the wash of color crosses over your drawing don't panic. By working confidently and resisting the temptation to fix up the edges, your shape will be clean and precise.
- As you become more proficient at making shapes you may wish to abandon the use of a pencil and draw with your brush.
- Remember that color may dry lighter than when it was first applied, so don't be timid when adding paint to your paper.

Paint a Multiple Color Graded Wash

As with single and two-color graded washes, a multiple color graded wash is most successful when the paper is dampened first. Color is once again dropped along the outside edge of your shape. As your loaded brush touches the moist paper, the color will flow across the paper and dissipate. The value of the color will decrease as it moves farther away from where it was applied to the paper.

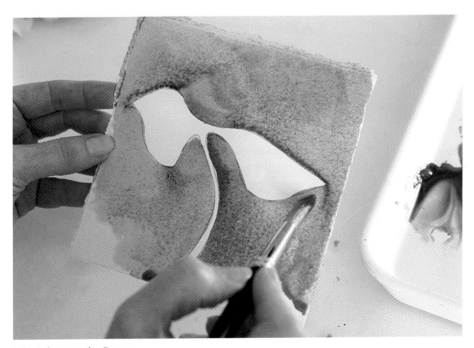

Mix Colors on the Paper

Charge—drop—in other colors and allow them to mix on the paper. You don't need to mix them on your palette. Encourage colors to mingle and flow by lifting and tilting your paper. Set the sample aside on a flat board to dry.

fixing edges

Here are some of the most common problematic situations that occur when surrounding negative shapes with color, and some tips to help you work through them. You will also find some helpful ideas to consider throughout the remaining projects.

Undesirable undefined shape Isolated shape

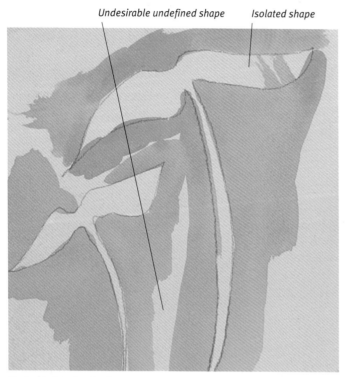

Paint to the edges of Fade out your color Connect one shape to
the paper with water another

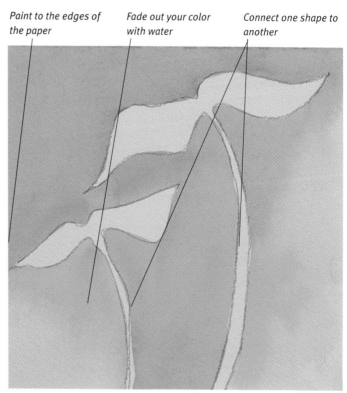

Undesirable Hard Edges

Hard edges that form from a lack of planning distract from your subject and create undesirable shapes. Every stoke you make creates an edge. Hard edges are desirable to define your shapes. Color that ends abruptly and without purpose, however, distracts the viewer from focusing on the subject you want them to see. When painting around shapes, it is necessary to plan not only where your color begins, but also where it will end. Lack of planning can result in floating, isolated or undefined shapes.

Solution

There are three possible solutions to help you avoid undesirable hard edges. If you like, you can combine all of the options together in one painting.
1. Paint to the outside edges of the painting. Suggest deep space by pulling your color right off the edge of the paper.
2. Fade out the color. Blend color with increasing amounts of water as you move away from your shape, to soften and wash away the edge.
3. Connect one shape with another. Plan the location of your next shape and fill in the negative space between them with color. It may be helpful to draw a few shapes with a pencil or watercolor pencil before beginning to paint.

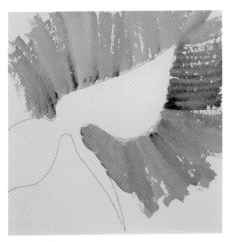

Ragged Edges

This choppy edge was made with a small brush that has been stroked outward, perpendicular to the form.

Solution—You can avoid rough edges like these if you apply the paint by following along the perimeter of the shape with long, smooth, even strokes. Follow the edge of your shape in small sections and then pull the color outward. Don't be tempted to outline the entire shape with color as this will create a halo effect. Always use as large a brush as you can handle and work quickly to cover as much paper as possible before the paint has a chance to dry.

Patchy Washes

Uneven, messy washes are a common concern. They are caused when the painter goes back into an area and attempts to revise it. This frequently occurs when the painter has not strategically planned. Plan your moves before you begin to paint. Decide where you will start, what colors to use and how you will end. Take charge—you are the art director.

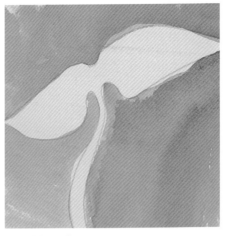

Indecisive Edges

Clean, crisp, descriptive edges are essential when building with negative shapes. The edges of your shape provide visual clues to the viewer as to the specific subject and the surface texture.

Solution—Practice, practice, practice. Indecisive and sloppy edges will cure themselves with repeated practice, so relax and enjoy. The more you paint, the better and more confident you will get.

Rough Edges

Impatience when making corrections results in poor or rough edges. It is almost impossible to produce precise, clean strokes on abused paper.

Solution—Repairs along edges can be quite successful. However, it is important to wait until the paint and paper are completely dry before attempting to correct an area by lifting color. A small, stiff bristle brush, such as those used in oil painting, works well to scrub or remove color. Moisten the brush with water and gently scour the undesired area. Press a tissue against the surface to remove the loose paint. If a touch-up is required, wait until the scrubbed area is thoroughly dry before reapplying paint. Working on overly scrubbed, wet paper will result in a fuzzy mess.

Design Descriptive Edges

Edges perform as descriptive devices and are an effective design element. You can attract and hold the viewer's attention by sharpening—finding—edges in areas of interest. Hard edges generally advance. By softening—losing—edges you can create passages that allow the viewer to travel smoothly through the painting and also provide areas of rest. Soft edges recede and suggest distance. Be sure to provide the viewer with a variety of hard and soft, lost and found edges.

Outlining

When first attempting to paint around a shape, a common problem is the tendency to outline. When paint is applied in this manner around the shape, it will create a dark halo effect. As you outline, the paint dries quickly and is difficult to blend later.

Solution—Pull the paint directly out from your shape. Use the largest brush that you can handle. Work quickly in smaller sections.

correcting problems with color

Color can also be a challenge when first working with paint. Here are some snares to look out for and avoid, along with some handy tips for quick fixes.

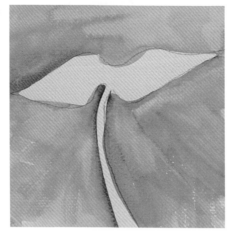

Paper Quality
Poor quality materials usually produce poor results. Paper that is either too absorbent or with surfaces that resist paint, as in this example, will cause frustration and unsatisfactory results. It is almost impossible to build layers on inferior pulp paper. Cheap paper is false economy.

Solution—When working with multiple layers, as in the projects in this book, it is essential that you use a good quality rag paper 90-lb. (190gsm) or heavier. For practice you can use scraps or the backs of unsuccessful paintings.

Streaks and Strokes
There are two reasons that unsightly streaks appear in your work. The most common is the use of a paint brush that is too small for the area being painted. The second cause is the use of paint that is too thick and, therefore, dries too quickly. Paint that is too dry does not spread or blend well.

Solution—Try using a larger brush. Increasing the size of your brush will help you work quickly. Your paint won't have time to dry before the next stroke is applied. Also, be sure you have plenty of color prepared and ready. You should experiment with different concentrations of paint and water to discover how much water is needed to allow the paint to flow from your brush yet remain saturated enough to retain the desired color.

Backruns Indecisive edges Poor edges

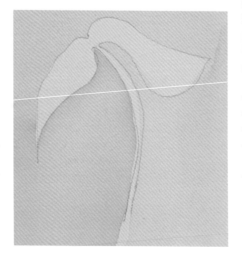

Patchy washes Streaky paint

Timid Color
It is difficult not to be overly cautious or timid when first attempting something new, but, weak applications of color are often the cause of disappointing results.

Solution—It's only paint and paper. Forge ahead with brave color. Don't dilute your wash with too much water. The color will most likely get paler as it dries. You may need to overcompensate by using stronger hues than you think necessary.

Strong Overpowering Color
Strong darks are wonderful, but they can create a problem if you are attempting to build multiple layers. Deep values are difficult to cover and may stain any color that is painted over them.

Solution—There are times when you will want to employ aggressive bold color. However, if you wish to build layers, you will need to begin with color of a lighter value or thin your color with water and gradually progress toward dark values in subsequent layers. Staining pigments are particularly strong. When used with caution they are a welcome addition to your palette. They need to be used with restraint when glazing. Transparent nonstaining colors are a dependable choice when building gradual transitions in layers.

A messy wash can easily be corrected. Just glaze over it.

correcting poor visual connections

When planning a painting, aim to create a feeling of unity. Repetition of an element such as shape or color helps to unify the painting. Color should appear to flow continuously behind the positive shape. To allow the viewer's eye to move smoothly around the painting, paint the space on one side of your shape with the same color and consistency as the space on the other side. To create a more unified appearance, try connecting your negative spaces.

Repetition Isn't Random

When working on a large format, develop the negative space progressively from one area into an adjoining area, rather than randomly around the painting. Repetition of an element such as shape or color helps to unify the painting and direct the viewer's eye around the work.

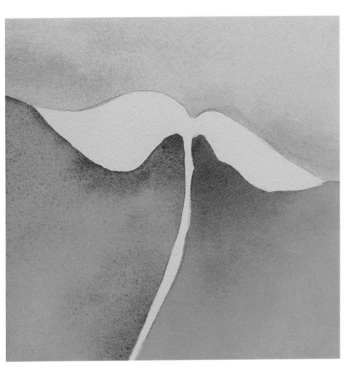

Poor Visual Connections
Cerulean Blue, Burnt Sienna and Permanent Rose have been used to paint around this shape. Each section was painted independently; there is no connection or visual flow between them. The spaces are broken up and lack unity. The viewer's eye jumps from one area to the next.

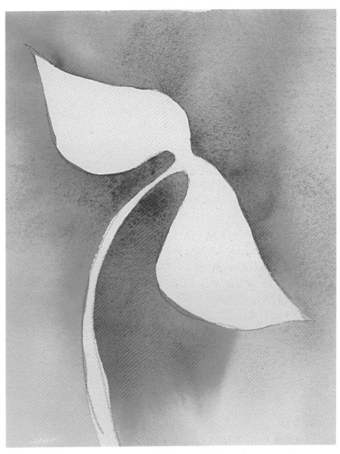

Consideration
This illustration used the same colors; however, they now blend together and flow across the paper. This gradual transition of color can be used to suggest the movement of light or atmosphere, or objects in the background.

Here, the entire area surrounding the leaf shape was wet with water before the color was dropped into the moist negative space. Permanent Rose was painted on each side of the stem to connect the space.

controlling backruns

Backruns *or blooms are terms used to describe phenomena that can occur when painting with watercolors. These uncontrollable ragged edges seem to appear from nowhere and creep across the page, usually in a most undesirable location, spoiling the piece of work. There are, however, occasions when you may wish to create this effect on your painting, such as when making natural free-form organic shapes such as flowers, snowflakes and stars. Understanding what causes backruns gives you the power to control when and where they appear.*

supplies		
	Watercolor paper	Ultramarine Blue
	1½-inch (38mm) flat brush	Cadmium Orange
	No. 8, 10 or 12 round	Spray bottle that produces a fine mist

1 PAINT A SIMPLE WASH
Paint a wash of Ultramarine Blue on a piece of watercolor paper.

2 DROP IN ANOTHER COLOR OF PAINT
Just as the shine is leaving the surface, but while the paper is still moist, drop in a load of wet Cadmium Orange paint. The new watery paint pushes the previous layer of color back as the moisture flows into the damp area.

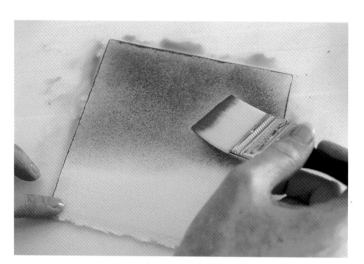

Your Personal Mark

The marks that you make on paper and the quality of your edges are part of your personal signature. I like clean, precise edges on my shapes but rarely do I accurately follow the pencil line. This is a compromise between accuracy and speed I need to make. How exact you are with your edges is, of course, your choice. Attempt to work toward control, but not at the expense of the joy that the freedom of spontaneity brings. You may eventually find, as I do, that it is easier and faster to paint your shapes without predrawing them.

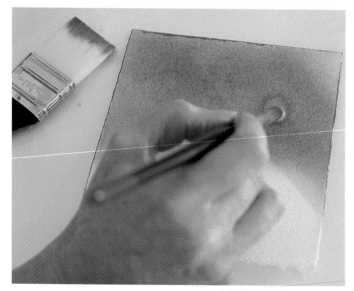

Key Note

Adding wet to moist creates a backrun.

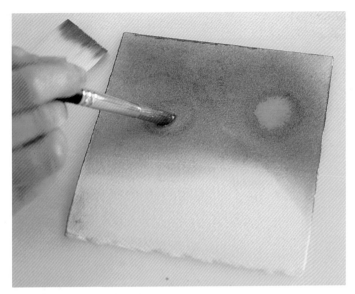

3 DROP IN WATER
Apply a drop of water from the tip of a brush to the damp paper.

4 SPRAY A FINE MIST OF WATER
From a distance of 12 to 20 inches (30 to 51cm), mist the air above the damp paint with a fine burst of water from a spray bottle. The droplets of water will fall to the surface and in several minutes, delicate, starlike backruns will form, as seen the in the painting on the following page. Although timing is crucial, this method is advisable over the use of corrosive salt on your painting to produce similar effects. Backruns like these are interesting and wonderful in the right places, but result in havoc when smooth washes are required.

Beating Backruns

Once the shine has left the paper, touch the surface gently with the back of your finger. (Using fingertips will leave oil on the surface and disturb the paint.) If it feels cool, the paper is still damp and will most likely cause backruns when wet paint is dropped in or if it is splashed with water. Misting the air above a painting at this time will produce tiny starlike speckled backruns. If on the other hand the surface of your paper shines, it is still wet and can be safely painted into without producing a backrun. Be sure to use slightly less water mixed with your paint. By adding fresh paint that contains less water and more pigment, you will avoid the appearance of undesirable backruns. If despite all your efforts and good timing a backrun still appears, you can cover most unsightly marks with a new layer of color.

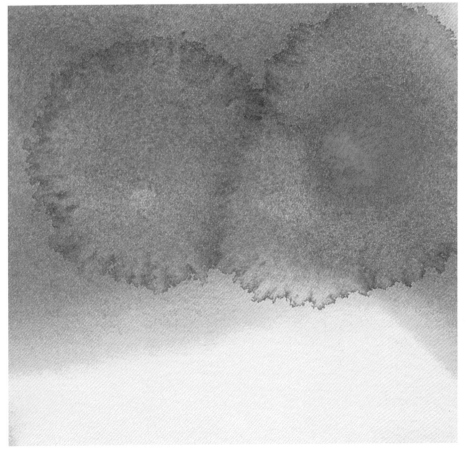

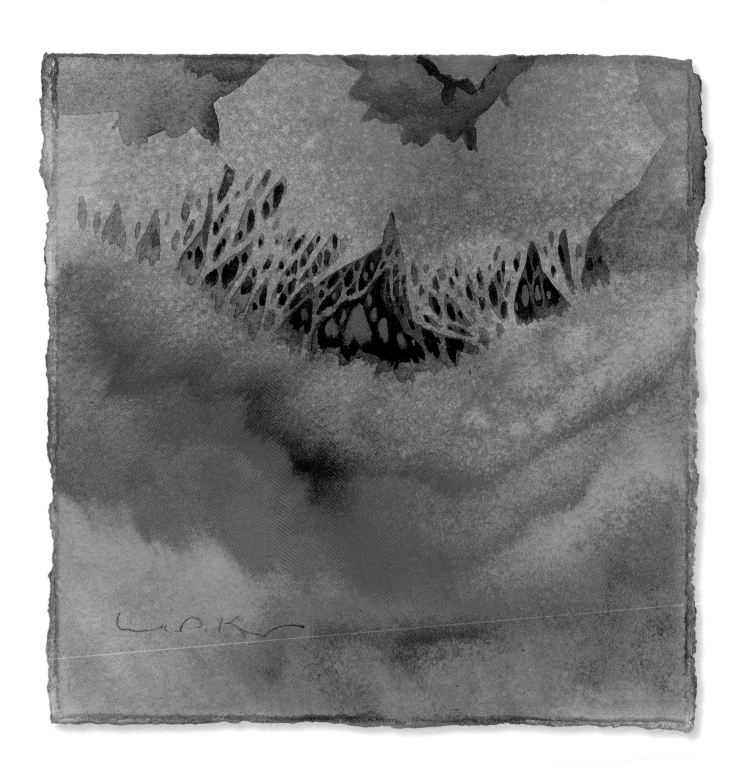

SHIMMER—LANDSCAPE MIRAGE SERIES
Watercolor
8" × 8" (20cm × 20cm)

working with glazes
and building layers

Making the shift from positive to negative shapes is just the first step in creating with this alternative approach. Building multiple layers is the real challenge and is when the fun begins.

The following projects have been designed to teach you how to weave your negative shapes together and to build with layers for a variety of subject matter. Along with learning how to glaze colors, you will discover two different strategies for working in the negative: how to develop florals and still life arrangements by working from the front to the back, and how to build landscapes from the ground up. The final results of the basic exercises may look unimpressive and rudimentary to the untrained eye, and you certainly wouldn't submit them to an art exhibit. In fact, you may be wise to hide them away from some of your more critical relatives, as they may think you have completely lost your mind. Do, however, keep the samples for future reference and share the ideas with sympathetic painting pals. Discussing the procedures will help to reinforce the concept.

If the finished assignments resemble highly patterned wallpaper swatches, you have probably done them correctly. Keep in mind that the goal, at this time, is to learn a strategy and not to paint stunning works of art. That reality will soon follow.

glazing to build layers

When you build layers in the negative, you will be creating new shapes, levels and colors by laying colors one on top of another. This method of applying paint in overlapping thin layers is referred to as glazing. While the process may take a bit of time to develop, the results are intriguing and handsome. The painting evolves gradually, allowing for modifications that range from minor adjustments and fine-tuning to major overhauls. Glazing can be used throughout the painting process to build or adjust color and to make corrections.

Glazing is easy. The best results are achieved with a soft round or soft flat brush. Natural hair, sable or sabeline work best because a stiff brush may disturb the underlying paints. You may use any color, but I recommend that you start with a light to medium value. I like to use paint that has been freshly squeezed from the tube and thinned with a bit of water, but you may also reconstitute paint that has dried on your palette. Take care not to disturb the underlying layers of paint. When building multiple layers, be sure your painting is completely dry before adding another glaze.

For descriptive crisp edges, it is essential to allow each layer to dry before applying the next glaze.

Painting the First Layer

I painted the swatch of Cobalt Blue onto a piece of watercolor paper and let it dry completely. To speed drying, I used a hand-held hair dryer. On larger paintings, I work across the surface, allowing one area to dry, while working on another.

Painting the Second Layer

I added a little more water to the paint on my palette to produce a slightly thinner version of the same color. I applied a few strokes of color over the first swatch and allowed the glaze to dry.

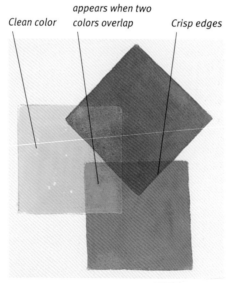

Clean color · A new color appears when two colors overlap · Crisp edges

Controlled Glazes

These colors and edges are clean and crisp. Each layer of paint was allowed to dry completely before the next layer was painted. New color has been created by layering, rather than mixing. The glazes are well controlled.

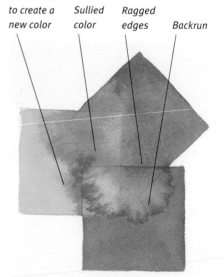

Colors mix to create a new color · Sullied color · Ragged edges · Backrun

Uncontrolled Glazes

Ragged edges, dull color and backruns are indications of layers that have been painted before the previously painted area was absolutely dry. The glazes are not well controlled.

glazing to modify color

Glazing can be used in repeated layers to build subtle colors, or used over a color to modify the value, hue or intensity. *Value* is the quality that distinguishes between a light and a dark color of the same hue. The term *hue* identifies color on the color wheel. It is the color name, such as red, orange, or blue. *Intensity* describes the strength of a color in terms of purity. Color at its most intense is pure, clean and bright, whereas less intense color is neutralized, dull or grayed.

Generally as you add layers, the colors naturally become darker and duller. The original hue, value and intensity are altered by the addition of these new layers. For this reason glazing works well when you construct your painting from light values to dark or from pure color to neutral. It is also possible to develop your paintings from dark to light with glazes of opaque paints. Transparent watercolor allows the previously painted layers to show through. You can also achieve this effect using paints that are more opaque, but they will need to be well thinned with water and fewer layers can be successfully developed.

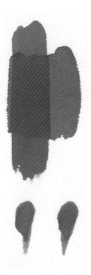

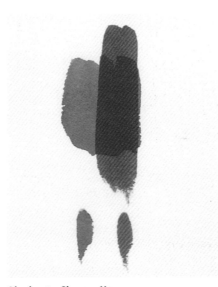

Glazing to Change Value
You can change the value of a color by applying an additional layer of the same color over it. Begin by laying down a fluid wash of color and allow it to dry. Thin the same color slightly with water on your palette and then paint directly over the area you wish to darken. By starting with light to middle values, you can build many layers. The more layers you paint, the darker the value will become.

Glazing to Change Hue
Hue is changed by glazing over the original color with a second, different one. In this sample, a layer of Cobalt Blue was painted and allowed to dry. It was then glazed with a thin layer of Quinacridone Red. A violet has been created where the red covers the blue.

Glazing to Change Intensity
Once again, a swatch of Cobalt Blue was painted and allowed to dry. By adding a bit of orange (the complementary color) to the blue, it becomes less intense or duller. The first layer is bright and clean, while the subsequent, overlapping glaze is less intense. With this approach to glazing, the painting progresses from clean to neutral as the layers are developed.

build layers with positive and negative approaches

These samples illustrate the difference between layering with positive shapes and negative shapes. With both approaches, the values increase from light to dark in these illustrations.

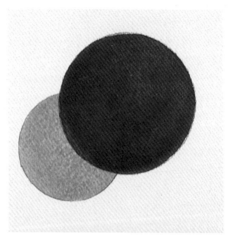

Layering With Positive Shapes
A second shape is drawn overlapping the first one. Additional shapes are placed in front of the previously painted forms. Fill the second shape with a darker value of the same hue. This is the method typically used by most painters when building a painting.

Paint a Positive Shape
Begin by drawing a shape, then paint inside the lines to fill your shape with color.

Paint a Negative Shape
To create a painting using negative shapes, begin by drawing a shape onto your paper. But instead of filling the shape with color, paint around it; you will be painting outside of the lines.

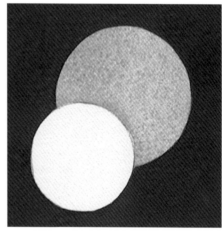

Layering With Negative Shapes
In the second step of the negative approach, the new shape will be tucked behind your first top shape. Again paint around the shapes, not inside of them, with a darker value of the same hue. Any additional shapes are placed behind the previously painted forms.

create layers using negative shapes

This project provides a working key to the negative, or subtractive, approach when painting most subject matter such as florals, intimate studies of nature and still life. It is an essential exercise that I use in my workshops to teach students to see and understand the process of creating layers with negative space.

For your first effort, use one simple shape. This will be repeated throughout the painting. Use just one color, but increasing values of that hue. Apply the paint in smooth, uniform layers. It is imperative that you draw only one layer at a time. It may be tempting to draw the entire plan before beginning, as this may be what you were taught to do in the past, but when working in the negative it's an entirely different process.

Practice this exercise until you can confidently see and understand the concept of negative space. Your first attempts may appear awkward, but be patient and work slowly. It is necessary to think about each shape you make with each layer of glaze you paint.

supplies

A 5" x 7" (13cm x 18cm) piece of good quality watercolor paper 140-lb. (300gsm) or other weight; you may wish to use a lightly tinted under-painting

No. 8 or 10 round brush

Pencil

Handheld hair dryer (optional)

Cerulean Blue

Cobalt Blue

Phthalo Blue

Ultramarine Blue

Points to Remember

- Build the layers from front to back. Paint the objects that appear closest to you first and work your way back.
- Paint around your shape.
- Do not paint inside any of your shapes.
- Do not paint over any of your shapes.
- Pull the color from one shape to another or out to the edges of the paper.
- Draw new shapes behind or under existing shapes.
- Grade values from light to dark.
- Light values advance while darker values recede.
- Dry between layers.

1 DRAW THE FIRST LAYER
Draw three circles on a small piece of watercolor paper. Isolate the individual shapes from each other; they must not touch or overlap. Don't worry about composition at this point but be sure to include a variety of sizes.

2 APPLY THE FIRST WASH
Surround your shapes with a light-value wash of Cerulean Blue. Pull the paint away from each shape and out to the edges of your paper. Your shapes will remain the white of the paper. Make the edges of your shapes precise and allow the painting to dry.

3 DRAW A SECOND SET OF CIRCLES
Draw a second set of shapes on your sample. Be sure to vary the sizes of your shapes and layer them underneath the first set. Align the shapes to one side so that you are not making a bull's-eye.

4 PAINT A SECOND LAYER

Paint a layer of Cobalt Blue around your shapes. This second layer of transparent color darkens the value. Do not paint inside any of the shapes. You will notice that the first set of circles remains white. The light blue color that was used for the first layer of paint is now enclosed by the second circles. Three layers have been created with two applications of paint.

5 DRAW THE THIRD LAYER

When the second layer of paint is dry, draw your third set of shapes. Repeat them, shift them, change their sizes. Once again tuck these shapes behind all previous shapes.

6 THE THIRD GLAZE

Glaze around the initial and new shapes. Use a heavy application of Cobalt Blue or Ultramarine Blue to darken this layer. Remember, don't paint the interiors of any shapes.

7 FINAL—FIVE VALUE STEPS

Continue in this manner to build your painting layer upon layer. The addition of a dark-value hue such as Phthalo Blue will give you the rich darks required for the final glazes. I have built five layers in this sample, but you don't need to stop there. By making the transition subtle between value steps you can create even more.

Tips

- If you have trouble making nice round circles use paper templates, bottle tops or coins of various sizes as patterns.
- Variety in the glazes and backruns are to be expected; that's the nature of watercolor.
- Don't worry. You will be able to cover any unattractive areas with subsequent layers.

Initial shapes are the white of the paper

The first application of Cerulean Blue is enclosed by the second set of circles

The second application is Cobalt Blue

Write yourself a note and repeat out loud: I am not painting the circles, I am painting the space around them.

changing color properties with glazes

Try changing the hue with layers. Begin with yellow followed by a layer of orange then red. Next, explore the development of a sample based on changes in intensity. Beginning with a clean pure color, such as orange, follow with a second layer that has been neutralized by the addition of its complement blue or a little black. Subsequent layers will include more of the complementary color until a neutral gray or dull brown is developed.

Key Note

Still don't get it? Don't distress. If after working through the exercises you still are having trouble grasping the concept, don't worry. It doesn't mean you aren't smart, or that you're not a good painter. Be patient. After all, you have been thinking and seeing the way you do for all of your life; and it may take a bit of time and repeated practice to make the visual shift. You'll get it. When it finally happens, it is as though a light is switched on. You'll say "Oh, now I get it."

Building With Changes in Hue
In this sample I changed the hue from one layer to the next. I began with an underpainting of Cadmium Yellow. Each of the following layers was glazed with one hue only, beginning with Cadmium Orange, Quinacridone Magenta, and lastly, Cerulean Blue.

Building With Changes in Intensity
This sample changes in intensity. I began with an underpainting of Cadmium Yellow. Subsequent glazes were neutralized by the addition of Cobalt Violet and Black.

Making a Statement with Personal Symbols

What images do you like to paint? When you feel confident with the concept, try incorporating a variety of forms together. Combine squares with the circles or use interesting shapes of your own. Create descriptive, personal shapes to make your own symbols to suggest anything such as fish, butterflies, umbrellas, flowers, birds or buildings. For more complex forms, use patterns cut from paper.

build layers with multicolored glazes

In the last project the glazes were applied as flat, homogeneous layers: one color per layer, laid down evenly across the surface of the paper. The samples also had a consistent number of layers throughout. Now it's time to put your watercolors to work, doing what they do best. In this project you will use multi-colored glazes, applied wet-into-wet, creating soft washes that blend and diminish. Some areas of the sample will have numerous layers, while others may have fewer. The shapes are a little more complex, but the approach to building layers in the negative is the same.

supplies		
	A small piece of 140-lb. (300gsm) watercolor paper	Pencil
		Cerulean Blue
	1 or 1½-inch (25 or 38mm) soft flat brush	Burnt Sienna
		Phthalo Green
	No. 10 or 12 round brush	

1 PREPARE AN UNDERPAINTING
On a piece of 6" x 6" (15cm x 15cm) white paper, apply a light-valued, wet-into-wet wash of Cerulean Blue, Burnt Sienna and a touch of Phthalo Green.

2 DRAW YOUR SHAPE
Draw a simple leaf shape on the dry underpainting. Include a slender, curving stem. Dampen the area surrounding the leaf and stem with clean water. Drop in more Cerulean Blue, Burnt Sienna and Phthalo Green. Lift and tilt the paper to encourage the paint to flow and mix. Allow the painting to dry.

3 DRAW THE SECOND LEAF
Draw a second leaf behind the first leaf. Make sure it's stem passes underneath the first stem. Dampen the area around the two leaves with clean water. Glaze around both leaves using the same three colors. Paint close to the leaves but don't paint into them. The paint should have slightly less water and more pigment than the previous glaze. As you work out from the leaves add more water to the paint to diffuse the strength of color and reduce the value. Carefully paint in the small captured negative spaces between the leaves. Allow the painting to dry.

Create Connections

For good visual connection, be sure to paint the air (negative space) on one side of an object the same color as on the other side. See chapter three, page 49.

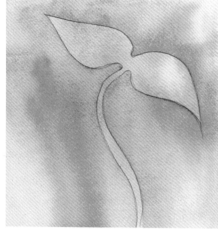

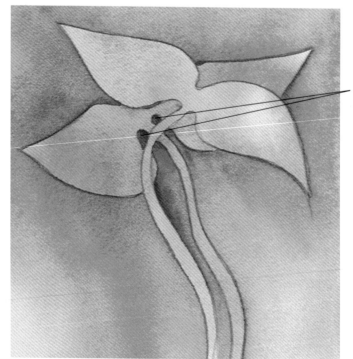

Captured negative spaces

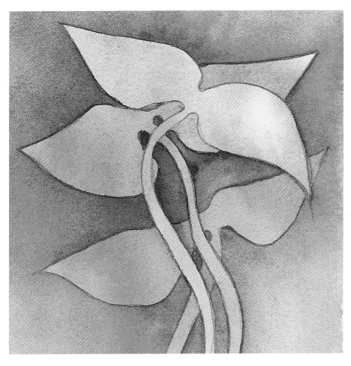

4 PAINT THE THIRD LAYER
Sketch a third leaf behind the first two. Re-wet and apply color around your shapes and within the captured negative spaces. This time concentrate the darks in one area and allow the remainder of the painting to be a lighter value. To achieve this effect, apply a dark glaze in a selected area and use paint of a lighter value in others, or dilute the dark color with clear water as you work around the remaining shapes. Some areas may be left without further glazing. Allow the painting to dry.

5 APPLY THE FINAL GLAZE
Repeat the process so the final painting has four layers of paint in addition to the underpainting. The stems within each set of leaves should appear to be continuous as the eye weaves the shapes together, visually connecting the pieces.

Limit Detail

As tempting as it may be, do not paint in details such as veins or bugs. They aren't needed and they will only confuse you when you are focusing on creating in the negative.

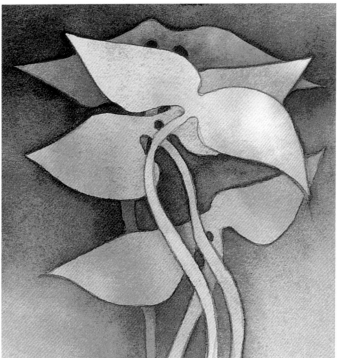

Variety in direction will establish balance and create movement.

create landscapes with layers

If you are accustomed to painting your landscapes by filling in one shape after another, beginning with the sky and working down from the background through the middle ground and finishing with the foreground, you might like to try a different strategy. To paint landscapes with a different approach, work from the bottom of the paper to the top, beginning with the closest shapes and moving upward to those farthest from you. You will be working in the negative and most likely in reverse of your usual approach.

The objective of this project is to incorporate your glazing skills to create bands of color which increase in value as the layers progress up the paper, simulating the effects of the horizontal strata frequently seen in landscapes. Use just a single color, such as Viridian, and observe the number of layers of increasing values you can produce.

supplies	Small piece of 140-lb. (300gsm) watercolor paper	1-inch (25mm) or larger flat brush
		Viridian

Tips

- As the paint is layered, it naturally darkens. Simply decrease the amount of water in your paint mixture as you build your layers. As the tiers progress the paint needs to be thicker to provide the increase in value required. Watery, diluted paint is thinner and lighter. Alternatively, less water makes for deeper value.
- To create interest be sure to vary the spacing between layers.
- Repeat this exercise but change the hue and intensity of the colors.

1 FIRST LAYER
Paint a wash of Viridian evenly over your watercolor paper using a soft flat wash brush. Start near the lower edge and drag the strokes horizontally across the surface. Leave a narrow band of white at the bottom of the paper. Fill the paper with even color. Allow the paint to dry.

2 THE SECOND LAYER
Dilute the Viridian with water and apply a second layer directly over the first. Leave strips of the initial light value and the white at the bottom. Alter the length of the wave so that some areas of the lower band fluctuate from narrow to wide. Allow the paint to dry.

3 CONTINUE TO BUILD LAYERS
Continue to build your layers from bottom to top. The final layer has been diluted with only enough water to permit the paint to spread. Remember, each layer must be completely dry before more paint is added or you will lose the crisp edges and your layers will melt together. Using just one color, several layers have been developed that suggest smooth rolling hills or waves.

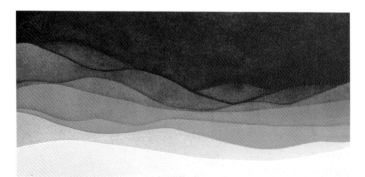

the cutting edge: creating descriptive landscape symbols

Smooth undulating bands of color are fun to paint and work well if all you want to suggest are gently rolling hills. But what if your landscape includes sharp mountain peaks, blowing grasses, buildings or neatly cultivated orchards? By incorporating descriptive edges with your layers you can depict an array of interesting land-

forms, manmade structures and natural elements. These landscape symbols, which are created with the negative approach, are easy to establish when you begin with rudimentary shapes and then cut away at the forms to provide specific informative edges. Here's how to go about it.

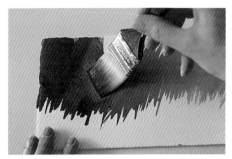

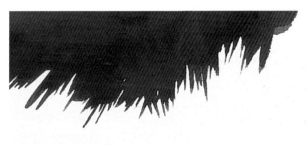

A Band of Blowing Grasses
This rough jagged edge can suggest heavy grasses in the foreground or middle ground of a landscape.

Texture Appears at the Edge
The top edge of blowing grass is irregularly serrated and the wind-whipped blades move wildly in different directions. Begin by cutting the top silhouette of the grasses with the edge of a flat brush. Pull the color up or dilute with water gradating the wash to the top of the paper.

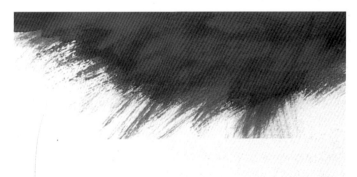

Using the Dry-Brush Technique
An actively applied dry-brush technique is an alternative method that indicates a textured field of blowing weeds. The dry-brush technique results in finer textured edges to produce softly blowing weeds.

Think Shape First
To make a coniferous tree, begin by cutting around the shape of a tall triangle with a wide, flat brush. Pull the color up and away.

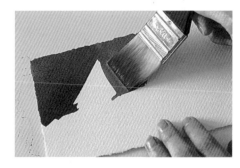

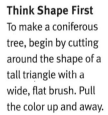

Define the Descriptive Edges
Cut into the triangle with a round brush to delineate the bows. Vary the depth and distance between the notches.

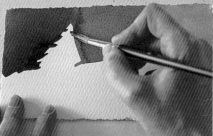

Vary Your Shapes
Nature provides us with a range of sizes in trees and varies the spaces between them.

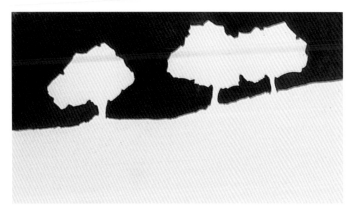

Try a Different Shape

These deciduous trees begin with modified circles. Shape the lobes by repeating the curving strokes with a round brush. Variety in the width of the band of negative space suggests a gentle slope. To indicate an orchard of fruit trees place the tree forms equidistant from each other.

Think Big

Consider uniting like elements to make one big shape. Rather than painting each object separately, combine them to make a single large form. This sharp angular band suggests mountain tops, or sharpen the angles to denote the sails of boats. These edges were cut with a large flat brush.

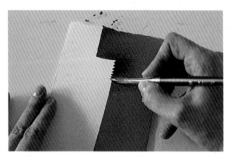

Create a Silhouette Fence

To paint a picket fence start by painting a straight band of color that marks the top of the fence line. Use a small round brush to bite into the lower edge of the band of color at close and regular intervals to produce the serrated top of a fence.

Have You Noticed?

Straight, horizontal and vertical forms, uniformity in size, shape and precise spacings suggest man-made constructions. Curvilinear and angular forms, dissimilar in size and shape and with random spacing is nature's way.

Combining Multiple Elements

Anything found on one level can be combined to make the layer. Your band could include a medley of flowers, grasses, bushes and a mailbox. A sharp angular roof line, rectangular chimney and walls create a negative symbol for a house. There is no need to paint in bricks or siding.

Getting Personal

Here is your chance to make your paintings personal. You will need to spend time investigating the aspects of landscape you find most intriguing to really see what the silhouetted edges and shapes look like. Keep things simple and completely eliminate or minimize any interior details. Build your repertoire to include numerous geometric shapes such as boats, castles, apartment buildings and drying laundry. Also include organic shapes of specific types of flowers, bushes and cloud formations. The goal is to keep your shapes simple with interesting, distinctive edges.

breaking down descriptive layers

You have seen how overlapping a series of colored bands can suggest a landscape and that in order to make the bands informative they need revealing edges. Now you will see that by combining a number of these descriptive layers, the landscape becomes entertaining, captivating and suggestive of time and place.

To work in the negative, these telltale strips of color are laid down from the bottom to the top of the paper. Landforms that are closest to you are painted first. To make your painting interesting, develop the layers with variety in shape, width, color and texture. Here is how the concept works.

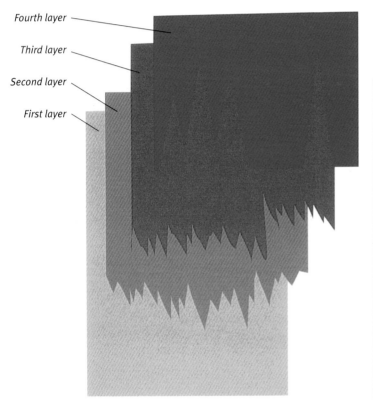

Fourth layer
Third layer
Second layer
First layer

Separated Descriptive Bands
Descriptive bands, similar to those you made in the preceding project, are laid down on top of one another, starting at the bottom of the paper and building up. The layers have been separated in this illustration to show each individual layer.

Layered Descriptive Bands
Now overlap and align the layers and you will see two rows of long grass (yellow then orange), a pale green field leading to four pine trees, and the blue sky.

build a landscape from the ground up

To assemble your landscape you will be layering a series of colorful strips that will delineate, in the negative, simple tree forms, shrubs and grasses. For this project, you will apply the paints in a variety of techniques: dry-brush, juicy washes, highly diluted, and thick layers. Any and all of these applications can be incorporated. Follow along with the specified colors or choose your own. You may not like my selections— Cerulean Blue trees don't appeal to everyone—so go with your favorites, or try something unconventional. Your color choices can be anything from realistic to ridiculous. Anything goes, as long as you remember to dry each layer before adding more color, concentrate on forming specific, revealing edges and to glaze from the bottom up.

supplies

140-lb. (300gsm) piece of watercolor paper

1½-inch (38mm) flat brush

No. 8 or 10 round

Facial tissues

White gouache

Burnt Sienna

Cadmium Yellow

Cerulean Blue

Cobalt Blue

Permanent Rose

Raw Sienna

1 PREPARE A DRY-INTO-WET UNDER-PAINTING

Apply a light to middle-value hue to the surface of your paper. Briskly apply Raw Sienna with a dry-brush technique (see page 29) across the entire surface using a 1½-inch (38mm) flat. This will be the base color for the foreground layer of grass.

2 CREATE A GRASSLIKE EDGE

When dry, cut down into this foundation layer with a 1½-inch (38mm) flat to suggest a grasslike edge (see edge samples on page 63). Apply varying amounts of Cerulean Blue and Raw Sienna. Concentrate on the edge you are sculpting. Extend the color toward the top of the page. Thinning with water is optional.

Be sure to dry between each layer.

3 CREATE A SECOND GRASSLIKE EDGE

Use a flat brush to cut another grasslike edge with a mixture of Cerulean Blue, Raw Sienna and Burnt Sienna. Once again, extend this new layer of color toward the top of the paper.

4 CARVE NEW SHAPES

Add more applications of Burnt Sienna, Permanent Rose and Cerulean Blue directly on the dry paper or drop them onto newly dampened sections. Allow them to mingle as multiple layers of grasses and small shrubs are created and the layering progresses from the foreground towards the middle ground.

5 GLAZE WITH AN OPAQUE

Apply an opaque Cadmium Yellow to veil darker hues while blocking in the top of curving bushes.

6 Define and Edge

Drop Cobalt Blue and Permanent Rose along the prewet edge and dilute them as they move upward. As this dark color is applied, the rims of yellow sunlit bushes emerge.

7 Create Tree Shapes

Apply a solid coat of Cerulean Blue to form curving tree shapes. To cover the existing eight layers of paint, a deeper value or thick opaque paint is required. If you wanted a blue sky, you could finish now, but why quit when you're just getting started.

8 Lift the Paint

With this number of layers, the paint is getting rather thick and weighty. It is possible to lift color as an alternative option to introduce a lighter value in the upper areas of the painting. Create the suggestion of an irregular line of blue trees by moistening the negative space with water and gently scrubbing with a small bristle brush. Lift the color with a tissue.

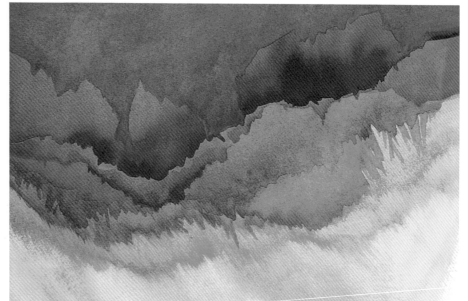

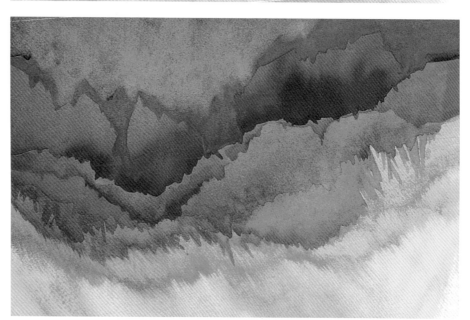

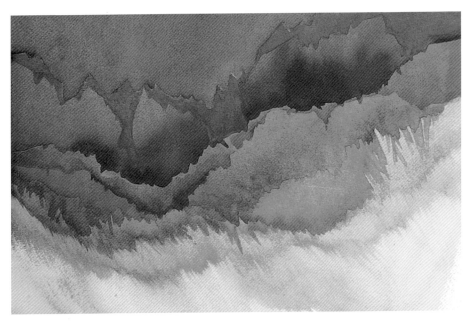

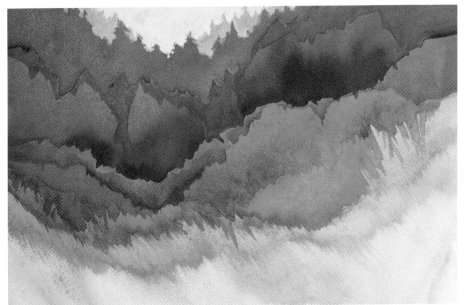

9 APPLY A WARM GLAZE

The previous layers of color have stained the paper so use your no. 8 or 10 round and brush a warm glaze of opaque Cadmium Yellow and Burnt Sienna over the lifted section to tone the paper and repeat the warm hue found in the foreground.

10 FINAL ROW OF TREES

Use your no. 8 round to create the final top two rows of coniferous trees using two opaque layers of White gouache tinted with Raw Sienna.

Why So Much Paint?

You may wonder why I suggest that each band of color be pulled up to the top of the paper. It may seem like a waste of paint and time. Remember that the color you are applying serves two purposes: to carve a descriptive edge for the landforms you are currently creating, and to lay down an appropriate hue for the future landform. It's imperative that you focus all of your attention specifically on the form you are cutting, its shape, size, direction and descriptive edge. It is most likely that you will not know exactly where the next layer you build will occur or end until the current one is established. So give yourself plenty of options by working the color beyond where you think the next landforms will end. You will need to be able to adjust your ideas and respond to the painting as it progresses and evolves. With more experience you will be able to reduce the width of each band of color. Remind yourself to work on just one layer at a time.

You will find some helpful reminders and considerations when building multiple layers in the negative on page 124.

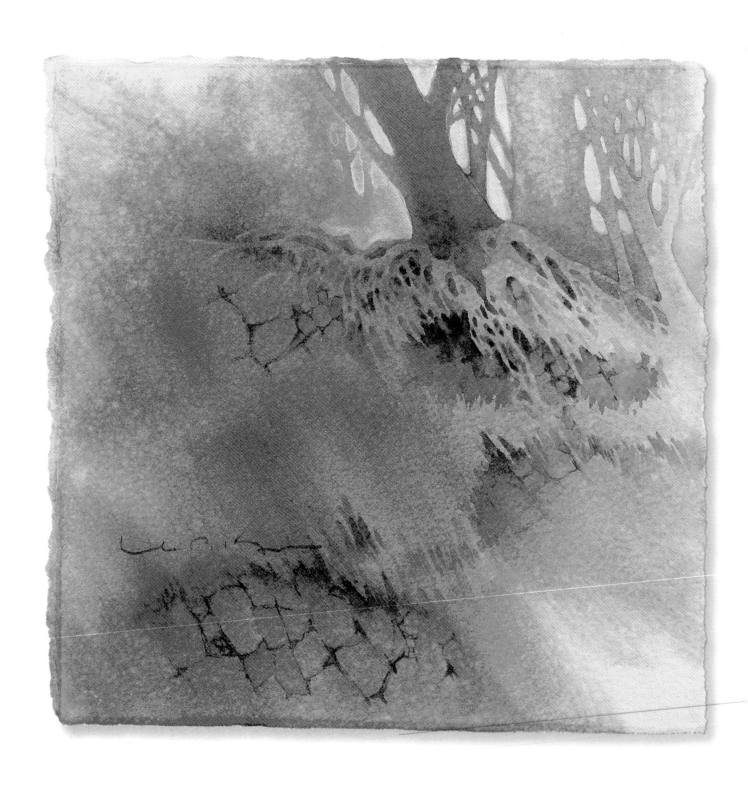

TIME SIGNATURE
Mixed water media
8" × 8" (20cm x 20cm)

building nature's
complex shapes

5

The enchanting mysteries of nature found in flowers, trees, foliage and berries, and in intricate patterns of light are captivating and can prove to be an enticing challenge to paint. To successfully capture the essence of a specific subject and combine it with its natural environment, you need to observe its unique qualities and how it responds to the surrounding elements. You must become intimate with the character and personality of your subject. Incorporating all the components and details can be a little overwhelming, for just as a neglected garden will quickly become overgrown and wild, so too can a painting of nature's complex shapes develop into a labyrinth of confusing forms and tangled lines. In this chapter you will find some straightforward strategies that simplify the task of depicting complicated, compound shapes and unravel the network of interwoven layers. These projects will show you how to make complex natural forms easy to paint. The secret is to start by planting one idea and allowing it to grow.

customizing shapes

There are many thousands of species of trees, weeds and flowering plants in the world, each having a distinctive silhouette and branching pattern. You couldn't possibly memorize every one, and you don't need to in order to successfully capture their character and essence.

Painting nature's complex forms is easy when you begin by establishing a rudimentary, descriptive shape and then pare it down to reveal a unique, individual identity. Begin by examining a single leaf:

What's the general outline? What's the shape of the leaf tip? The base? Are there indentations or lobes in the silhouette and are the edges smooth or serrated? Does the leaf curl? How is it attached to the stem? Does it grow individually or in a group, and how are any clusters spaced as they stem off of the main branch? Here I used an easy negative approach and modified simple shapes to give a basic form personal identity.

Start With a Basic Shape
I began by tracing around a template cut from paper or you can sketch the outline of a simple leaf several times on a scrap of watercolor paper. Because I was representing leaves with symbols, I concentrated only on the shape and didn't get sidetracked with unnecessary details such as vein patterns. I then flipped or reversed a few of the images.

Delineate the Form in the Negative
Using a dark color and my no. 12 round, I painted in the negative space surrounding the shapes.

Customize Your Shapes
I then cut into the edge of the first shape several times with the tip of my no. 8 round. This uneven scoring will suggest a serrated edge. On the second leaf I carved deep grooves with a 1-inch (25mm) flat. I then continued to create interesting and distinctive edges by using a variety of brush sizes and styles. You can create shapes that are natural or stylized. The choice is yours.

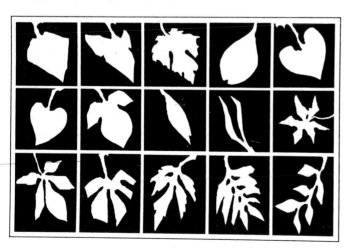

Tailor-Made Shapes
Here are a few leaf shapes that can be fashioned by carving away at a basic shape.

demonstration
unraveling the layers of foliage and fern branches

Making one leaf at a time is easy. Now try multiple foliage suspended on a common stem such as you might find in most species of trees, low-growing bushes, ferns and the greenery of floral bouquets. The procedure is similar to painting around a basic, single leaf. The cluster of leaves becomes a more complex shape, but remember that it is still just a shape.

supplies		
11" x 15" (28cm x 38cm) or smaller piece of watercolor paper	No. 8 round brush No. 10 or 12 round brush 1-inch (25mm) or larger flat wash brush	Cerulean Blue Phthalo or Cobalt Blue Raw Sienna Pencil

1 START WITH A PENCIL GUIDELINE
Begin by making a single, flowing pencil line on your watercolor paper. This will provide a guide for the stem and indicate the general curve and movement of the windblown branch. Start at the heavier end of the branch and stroke quickly toward the tip using one fluid motion to capture the graceful movement. This pencil line may be erased later.

2 PAINT THE SPACES BETWEEN THE LEAVES
Without overmixing, combine freshly squeezed Raw Sienna and Cerulean Blue with water. Place the tip of your brush close to, but not touching, the pencil line and pull the stroke down and away. The brushstroke should look like a teardrop, or comma, being thick and round closest to the pencil line, and tapered to a point at the end away from the line.

Repeat the stroke, decreasing its size, along the length of your pencil line to the tip of the branch. Although these strokes may resemble tiny leaves, they are actually the spaces between the leaves. You are creating the air holes between the leaves—the captured negative shapes.

3 REPEAT THE STROKES ON THE OTHER SIDE
Paint the captured negatives on the other side of the pencil line. Place them directly across from the first row of brush marks.

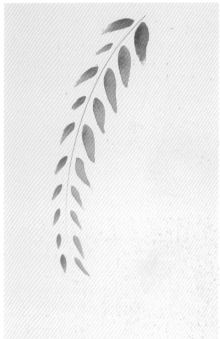

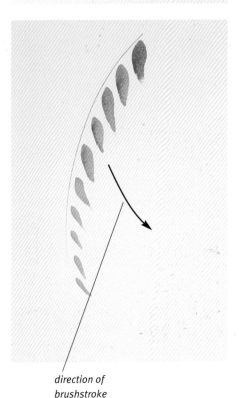

direction of brushstroke

Imitate Nature

To establish natural movement when painting a tree or plant, follow and imitate the direction of growth. Generally the stems and leaves become progressively finer and smaller as you move further away from the heart of the plant toward the tip. When painting a hanging cluster of leaves, start at the top and glide the pencil line in a downward sweep. Alternatively, to simulate the upward growth of ferns or saplings, begin at the bottom and quickly draw the line up.

4 BEGIN CARVING AROUND THE LEAVES

Load a large, round brush with the same combination of Raw Sienna and Cerulean Blue. Position the tip of the brush at the narrowest end of a previous brush mark. (My students say "Point the point at the point!") Now pull your brushstroke down and out at an angle similar to the captured negative spaces previously created. This line forms the lower edge of one leaf and the top edge of another.

5 DELINEATE THE LEAVES ON ONE SIDE

Continue to carve around your leaves. The shape you paint may look something like a saw blade with sharp angular teeth. Use a large flat brush and plenty of water to dilute the color as you pull it away from the leaves toward the outside edge of the paper. Soften and fade any undesirable edges that occur.

6 SCULPT THE OTHER SIDE OF THE BRANCH

Continue to cut out the edges of the leaves on the remaining side. Notice that the leaves are the white of the paper. You will need to work quickly. After the shapes are formed but before the paint has dried, use a no. 8 round to cut notches for serrated or wavy edges, typical in ferns and many other plants. Dry your paper thoroughly and erase the pencil line before proceeding.

7 WEAVE A SECOND GUIDELINE

The second layer of leaves will be partially hidden under the first. Weave a second pencil line through the spaces between the leaves. Once again paint the air holes—captured negatives—along your guideline. Using less water, dilute your paint to create a darker value. There will likely be fewer air holes to paint as some are obscured by the upper layer.

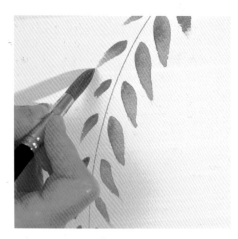

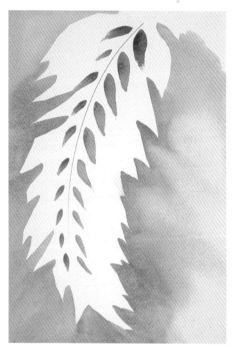

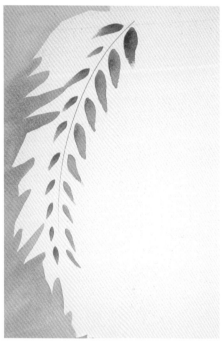

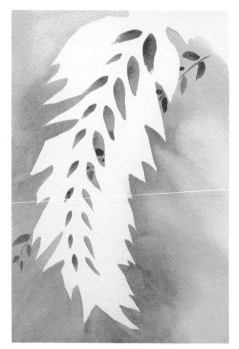

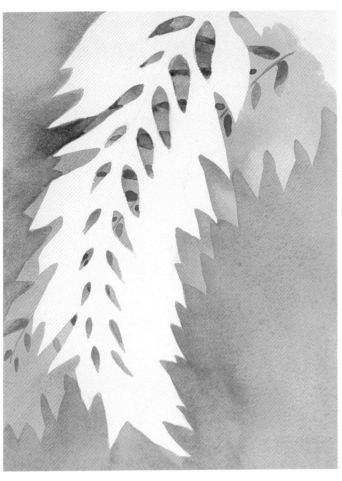

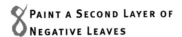

8 PAINT A SECOND LAYER OF NEGATIVE LEAVES

Using your guideline and the little air holes that you made as reference points, glaze around the second set of leaves. Be sure not to paint over the existing leaves and branches. Working on dry paper is the secret to maintaining clean, crisp edges.

9 ADD MORE LAYERS OF FOLIAGE

Continue adding foliage to your painting, further enhancing the value range and creating a more dramatic final layer. Add a touch of Phthalo Blue or Cobalt Blue to the Raw Sienna and Cerulean Blue to create darker values.

Create Layers

In some areas you will want to create numerous levels. In others establishing only one or two layers will allow for calmer and less intricate areas for your eye to rest.

painting the flavor of berries, cherries and grapes

The bunch of grapes or cluster of berries I chose to paint is very different from the succulent tasty fruits I look for at the market. The grocery store's compact, tightly packed bunches of uniform, flawless, round fruit may be delicious or win first prize at the fair, but they're boring to paint. I would much rather paint a sparsely endowed bunch that has a variety of colors, shapes, sizes and airy holes. When painting I look for clusters that twist and breathe, those with interesting shapes.

supplies

8" x 10" (20cm x 25cm) or smaller piece of 140-lb. (300gsm)

watercolor paper
No. 10 round brush
1½-inch (38mm) flat wash brush

Cerulean Blue
Quinacridone Violet
Ultramarine Blue

Symmetrical
Perfect symmetry of elements makes a visually uninteresting design. This form is static and boring.

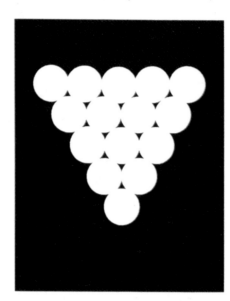

Asymmetrical
Exciting and interesting design is derived from variety within the elements. The form is musical and lyrical.

You will notice that with only minor additions and modifications, this project will make practical use of the circle exercise found in chapter four (pages 57–58).

Pre-draw your berries with a pencil if necessary.

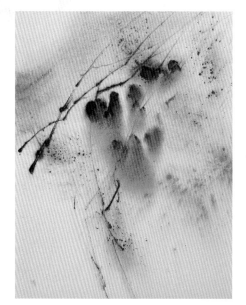

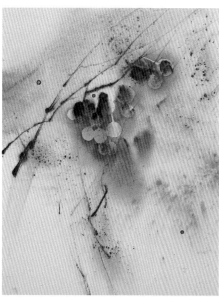

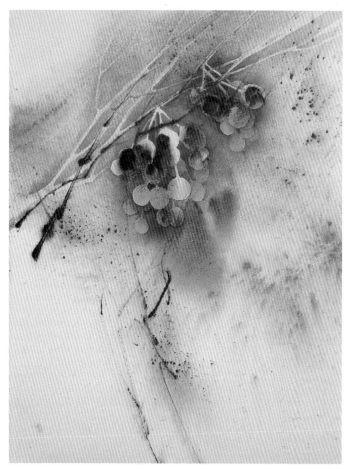

1 WET-INTO-WET UNDERPAINTING

Prepare your watercolor paper for painting wet-into-wet by wetting and mounting it on your Plexiglas. Scoop the tip of a no. 10 round into two or three colors—Cerulean Blue, Quinacridone Violet and Ultramarine Blue—of fresh, thick paint. Without mixing the colors on your palette, apply several spots of this rich, vibrant paint to the wet surface of your paper. Daubs are delightful; globs are glorious! Spatter the damp surface with flecks of exciting color. Allow the saturated hues to naturally soften and flow by lifting and tipping the paper. Set the completed underpainting aside to dry. (See wet-into-wet underpainting on page 26.)

2 ENCOMPASS THE BERRIES WITH COLOR

When the underpainting is dry, using the same brush, begin to carve around the shapes of several individual berries by encircling a few of the bursts of color with a thin glaze of Cerulean Blue and Quinacridone Violet. Make some of the berries larger or smaller than the extremities of the intensely colored spots and create a few berries where there are no color notes. Introduce a few slender stems by painting around them.

3 ADD LAYERS AND SCULPT THE BRANCHES

Tuck a new set of berries beneath the top layer of shapes. Vary the shapes and the negative spacing between forms. Increase the value of the color as you build by applying heavier glazes of the original hues. Blend and wash color away from the berries with clean water. Finish by delineating willowy branches in the negative. Connect the clusters of berries to the branches with a few graceful stems.

When working with the negative approach, if you don't like a shape you have made, you can reduce it or eliminate it completely by glazing over it.

capturing flowers that grow layer by layer

The negative approach is a fascinating and ideal way to paint florals. With this captivating method flowers grow before your eyes as they develop and radiate from the center outward. To avoid generic flowers that take on the appearance of fried eggs, you will need to begin by identifying and subtly exaggerating the characteristic shape and particular silhouette of the flower you wish to portray. Add specifically shaped petals, stems and leaves to create convincing daisies, sunflowers, zinnias, roses or other similarly constructed flowers.

supplies		
A small piece of 140-lb. (300gsm) watercolor paper	1-inch (25mm) or 1½-inch (38mm) flat wash brush	Cerulean Blue
		Raw Sienna
	No. 8 or 10 round brush	Permanent Rose or Quinacridone Violet

1 LAY A FOUNDATION OF SOFT TINTS

Begin with a loose wet-into-wet under-painting of Cerulean Blue, Raw Sienna and Permanent Rose. Use realistic color or let your imagination determine a more subjective selection. Drop soft tints of color onto your pre-wet paper and allow the paint to mingle, but don't overblend. Leave some areas white, however as even pure white daisies need a blush of color or the flowers will seem raw, stiff and cold. If you know where you wish to include leaves of a naturalistic green, lay in the base colors accordingly. Dry your underpainting completely.

2 ESTABLISH THE FIRST LAYER

This daisy will grow in layers from the center out. Keeping a flat circular form in mind, loosely draw the top petals of one flower with a pencil. Be sure to leave generous spaces between the petals. Use the existing hues of the underpainting as a guide for subsequent color choices and paint a thin delicate glaze around the petals. Drag the color toward the edge of your paper, diluting it with clean water as you move outward from the edge of the flower.

3 ADD A SECOND LAYER OF PETALS

When your glaze is dry, draw the next layer of petals. Tuck and shift them behind the initial shapes. This layer will peek out from behind the previous form. Once again, paint around the outside of the entire flower and in the small captured negative shapes between the petals with a sheer glaze, repeating the underlying colors.

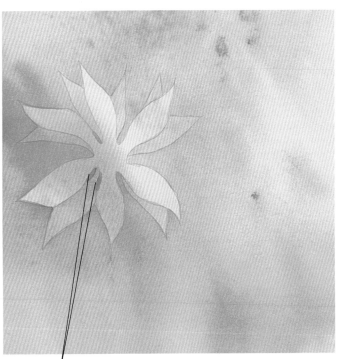

captured negative spaces between the petals

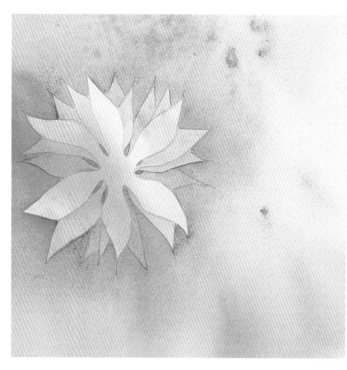

4 CONTINUE TO ADD LAYERS OF PETALS

Continue to build your flower by creating one or two more layers. Each new layer is positioned under the last layer of petals. Add variety to the petals by twisting them and changing their sizes. Because you are working in the negative and the goal is simplified floral symbols, don't go back into your petals to add details such as the stamens or veins.

5 SUGGEST A CENTER WITH THE NEGATIVE APPROACH

Use the negative approach to imply the solid yellow circle in the middle of the daisy. Rather than adding a positive, solid yellow, apply a delicate glaze in a circle around the center of the flower. Apply a small amount of Cerulean Blue and Raw Sienna with a no. 8 round sable brush on the thoroughly dry surface. The edge of the button is slightly serrated and softened with water to suggest texture and form. Use plenty of clean water to dilute the rim of color and wash it out from the center of the bloom. Avoid the temptation to fill in the center of the flower.

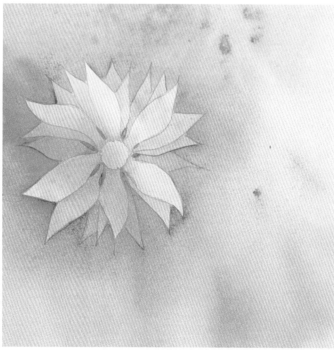

Remember: You are not painting the flower, you are painting around it.

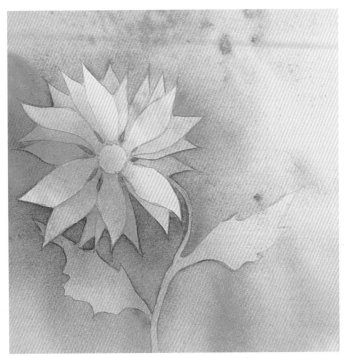

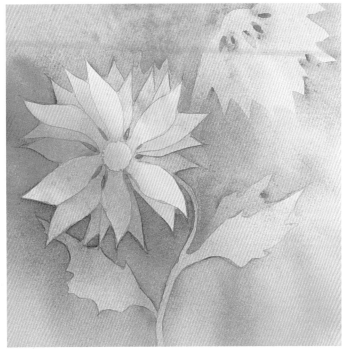

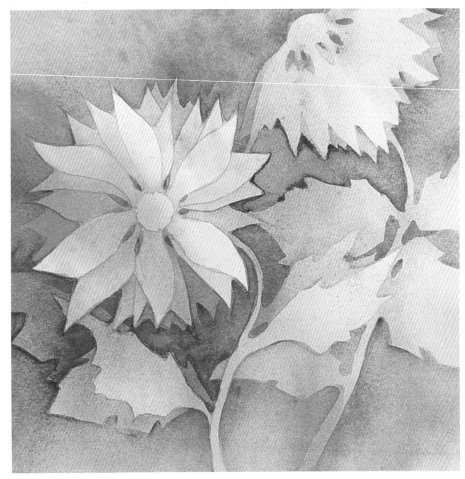

6 THE CURE FOR FLOATING FLOWERS

A stem and leaves can be added at any time throughout the layering process. It is important to ensure a visual connection with the center of the daisy. The midpoint of the flower is attached to the stem. The stem must be designed to be sturdy enough to support the weight of the flower, yet appear delicate with a graceful, natural curve. Glaze around the entire circumference of the foliage and stem. Repeat the underlying colors to maintain color harmony or glaze with a muted green mixed from the Raw Sienna and Cerulean Blue for natural color.

7 BEND AND TWIST

Keep in mind that if all of your flowers are of the same dimensions, color and position, the painting will be boring. Add interest to your painting by including a variety of sizes and changes in direction. Include buds and tip the flowers to different angles. To add a drooping daisy, begin by painting a semicircle of small strokes—the captured negative—and then glaze around the flower. Be sure to paint around the center of the flower.

8 AS THE GARDEN GROWS

Freely filling your page with leaves and flowers is a great way to practice. Don't worry too much about the composition in this exercise. Remember to maintain color harmony by repeating the value and strength of the original limited number of colors, rather than adding new hues.

painting trees: a bare bones approach

If you can weave or braid a few strands of wool together, you will find it fascinating to weave the limbs and branches of trees. It's easy when you begin with a simplified yet descriptive shape. Consider that the skeletal structure of a tree consists of the trunk, several major limbs, numerous branches and a multitude of fine twigs, but to create descriptive trees you will need to go beyond merely sticking a collection of these parts together. To evoke the mystery of a forest, make multiples of the rudimentary tree shape and begin the game of twisting and intertwining the forms.

Approach building the skeletal forms of trees in the same manner as you build a negative landscape: in layers from the bottom to the top.

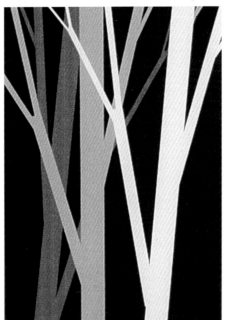

A General Shape is Not Believable
The shape on the left is not very believable as a tree. The limbs separate from the trunk at the same location and are a mirror image of each other. There is no variety in the width of the parts. The symbol on the right is interesting and more convincing as a tree. The limbs, branches and twigs all decrease in size. There is variety in the placement and direction.

An Intimate Viewpoint
The same tree symbol is reproduced three times, but the value and direction have been altered and the image is shifted or reversed. Changes in the design elements—size, shape, color, direction, placement and texture—serve to add interest and credibility to your forest. In this illustration a close-up or intimate view is presented as the trees extend from the bottom to the top of the picture plane. The depth of field is shallow—fairly flat—with little emphasis on foreground, middle ground or background. The viewer experiences the feeling of being in the woods.

A More Distant Viewpoint
To suggest distance or a deep interior, the layers progress upward in tiers from the bottom to the top. Consider that the picture plane is a shallow stage. Each layer is a flat screen laying one behind the other. The depth of field is more extensive and may include a foreground, middle ground and background.

A Cross Section of a Distant Viewpoint
As the layers of trees move further into the distance they rise up and back, like climbing a set of stairs.

weaving layers of trees

To paint the layers of interwoven tree structures, begin with a wet-into-wet underpainting. Apply the paint with vertical strokes of the brush to emulate the growth of trees. Spatter and splash color to soften the white of the paper and add texture.

supplies	No. 8 or 10 round brush	Cerulean Blue
5" x 7" (13cm x 18cm) 140-lb. (300gsm) cold-pressed water-color paper	1-inch (25mm) or 1½-inch (38mm) flat wash brush	Quinacridone Gold Phthalo Blue

1 PAINT THE CLOSEST ROW OF TREES

Establish the first or closest layer of trees by painting around the forms with a thin glaze of Cerulean Blue and Quinacridone Gold. Begin at the base of the tree and pull the glaze upward, angling out at uneven intervals to make allowance for the branches. Diminish the width of the trunk as the limbs split off. Allow the paper to dry thoroughly now and between all subsequent layers.

2 STEP INTO THE TREES

Move up the paper and begin the next layer of trees. Start at the base of the trunk and draw the tree form upward, stopping where a branch from the previous layer crosses. Because you are working in the negative the new trees will be partially covered by all previously established trees. Now start to weave the branches. The new branch passes under the first tree and reappears on the other side. Continue to carve out trees keeping your shapes simple. Be sure to vary the spacing between trees and include big, old trees as well as thin, young saplings. Allow the paper to dry.

It may be helpful to begin by predrawing the trees with pencil using the simplified tree symbol, on the previous page, as a guide.

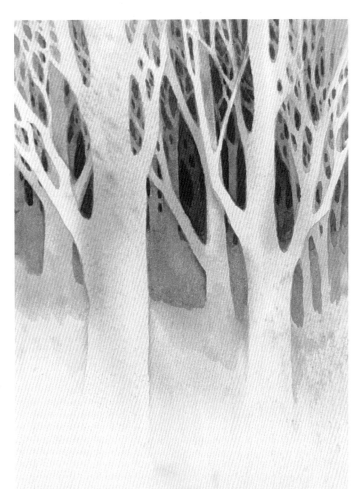

3 GO DEEP INTO THE FOREST

Once again move up the paper and begin a third row of trees using the same negative approach. Notice that the values increase from light to dark as the layers are built from front to back and bottom to top. Increase the tonal value of the color by adding a touch a Phthalo Blue to the Cerulean Blue and Quinacridone Gold mixture. Objects in the distance appear to be smaller than those up close. So to indicate great depth the trees can become thinner, but don't forget that there may also be a few larger trees in the deep forest.

Take Your Time

It takes time and patience to work the intertwining layers. Progress slowly and methodically across, and up the paper. As you work consider where the new branch will pass under an existing shape and where it will come out on the other side.

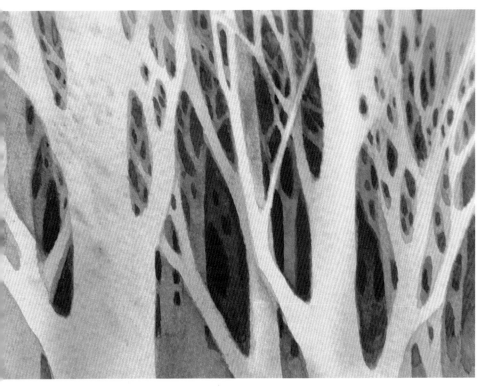

Detail—Play a Visual Game

In this detail you can see how the heavy limbs separate into thinner branches that crisscross and intertwine. Think of the project as a game in which you unravel a tangled maze of lines and shapes. This little exercise took me about one hour to complete. Before putting your brush down, carefully review your shapes. While every twig doesn't need to be accurate, check to see if the major limbs make sense. Do you have a branch that abruptly ends forming an unsightly stump, or a graceful, slender limb that swells to an awkward, cumbersome log? If so, simply trim, adjust and refine. Using the negative approach, it's easy to repair your work.

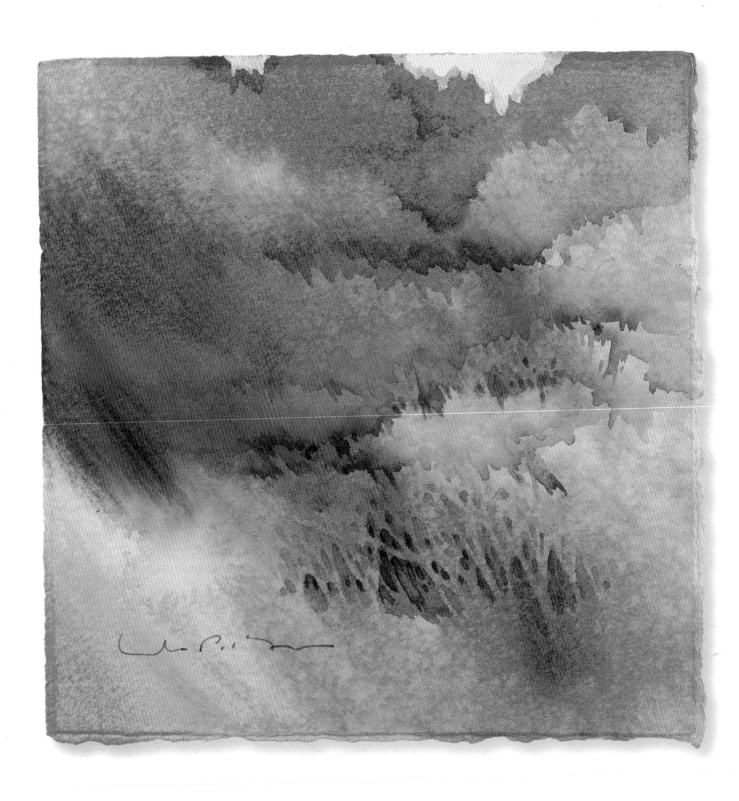

DISTANT MUSIC
Watercolor
8" × 8" (20cm x 20cm)

picture planning
made easy

There is so much to take into consideration when designing and planning a painting that effectively communicates with the viewer. However, determining how the parts relate to each other in a pleasing and unified way isn't as complicated as you might think. While I don't make the typical value plans, thumbnail sketches or even predrawn design, I do develop a plan. It only takes a few minutes of my time, but saves me hours trying to correct a bad composition.

Picture planning doesn't have to be painful. In fact, I'm hopeful that you will find my rather unsophisticated approach to designing your art logical and easy to use. This section will not teach you everything there is to know about design. Instead, its purpose is to offer up a user-friendly strategy so you will be comfortable setting aside a few moments to consider design options that will help you produce more effective and successful paintings. I will show you how to move beyond simply making pictures that are a collection of visual facts to creating expressive works of art that convey the essence and mood of the subject. You will be able to follow along with an uncomplicated, practical set of guidelines that are aimed at painters who prefer an emotion-directed approach to design. Throughout this chapter you will learn how to:

Identify the concept you want to express.

Simplify the concept in order to present a singular message well.

Eliminate unnecessary details and confusing information that don't contribute to the concept that you have selected.

Reorganize and arrange the elements in a pleasing way to reinforce the concept.

Exaggerate to entertain and inform.

Unify the elements through repetition to send a clear message.

the art of good communication

When it comes to communicating a feeling or sentiment, painting and chatting with a friend have a lot in common. Regardless of what emotion we wish to express, our body language, gestures and tone of voice all work together with the words we speak to convey our feelings. Every component needs to be in sync to truly convey a clear message. If one of these elements implies a different sentiment, the intention becomes confused.

Building an expressive painting, which clearly articulates your feelings and innermost thoughts, requires much the same unity of elements. To avoid the risk of sending a mixed message, getting sidetracked or losing your focus on what first inspired you to paint a particular subject, begin by pinpointing the important information and eliminating the confusing details and extraneous clutter. Your goal is to communicate an idea and establish an emotional connection with your viewer. In order to do this you need to decide what the real subject of the painting is. Simply put, what do you want to say?

In painting we don't have words, sounds or body language to tell the story. The words and gestures are replaced by the fundamental components of design. Understanding these elements and how to use them helps you present your ideas. Putting shape, size, color, placement, texture and line to work effectively communicates your concept and entertains the viewer.

Paint a Mood

Before jumping into a conversation or picking up a paintbrush, you need to make a decision about your intent. In the past you may have described the subject of your painting in an objective way such as a bouquet of daisies or the old mill. For a unique, creative strategy, aim for a more subjective and evocative vision when choosing subject matter. For an unconven-

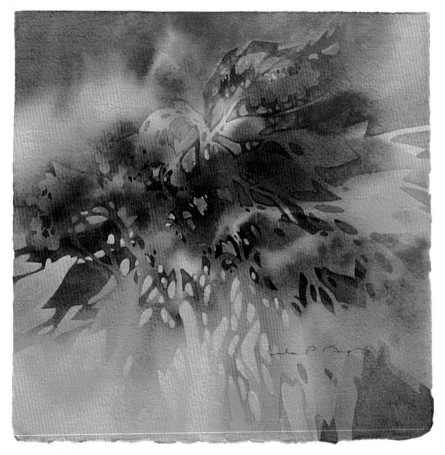

Morning Light

I am fascinated by the passage of time and the evolving seasons. The subtle transitions and constant movement of light from sunrise to nightfall leaves me filled with awe. In an attempt to capture a fleeting moment caught between the stillness of the night and the busy day, I have focused on the emerging, sharply defined leaves as they pierce through the gossamer veil of early morning mist. To keep the mood serene, value contrasts are minimal. Interest is created by the progression of soft forms to crisp ones, and cool hues melting away to a rosy warm glow.

watercolor • 11" × 11" (28cm x 28cm) • Private collection

tional approach, begin by selecting a feeling or mood as your point of departure. Choose from excitement, joy, tranquility, anger, fear, love, frustration or any other sentiment. Let your inner feelings guide you in this step. This choice of mood is to become the subject of your painting.

Once you have settled on the desired mood, you can begin to develop an overall plan that works to clearly communicate that feeling. The job of designing your artwork will become easier if you deal with each element in turn to determine how it effectively conveys your message. Each

design decision reinforces your objective, that is, to create a mood-inspired painting.

The elements of design, such as shape, size and color are not in themselves charged with emotion, yet undoubtedly, changes within the elements affect the way we feel. If making subtle adjustments in the components can impact the emotional connection you make with your viewer, why not take advantage of the opportunity?

Choose to say one thing well, rather than many things poorly.

shapes have personality

Regardless of whether you are working in the negative or positive, the predominance of one type of shape is one of the most influential factors that help establish a mood. As seen in chapter three, the basic shapes are the circle, triangle and square. Each of these shapes has its own demeanor that it brings to your paintings. All other shapes are combinations and modifications of these basic forms and personalities.

Inviting Rounded Shapes
The repetition of curvilinear or organic shapes suggests a soft, gentle or sensual mood. These rounded forms are inviting to touch or stroke.

Stable Horizontals
The predominant use of horizontal shapes works well to suggest stability and security, a feeling of repose, peacefulness and slow movement.

Inspiring Verticals
Stretch a square into a long vertical rectangle for a shape that feels spiritual and uplifting, or to create a sense of wonderment, growth or happiness. The wider the shapes are, the more stable they appear. Place thinner verticals higher up the paper and wider ones at the bottom to suggest depth.

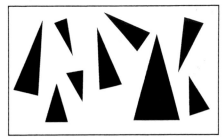

Dynamic Diagonals
Angular or geometric shapes are exciting and highly energetic. Triangular forms can be interpreted as joyful or dangerous. Although the well-balanced equilateral triangle is stable, just tip and elongate the shape to suggest movement, instability and danger. It would certainly hurt if you fell on these shapes.

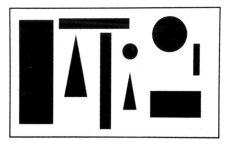

Random Shapes
If it is confusion or chaos you are after, a random mixture of shapes will serve you well.

Important Note

I'm not suggesting that these designated prejudices concerning size and shape are truths, just how they are commonly perceived.

Large Shapes Are Loud and Aggressive
By comparison, big shapes are generally powerful and more demanding than smaller, identical shapes of the same hue, value or intensity.

Small Shapes Are Active
Small shapes create movement and can appear effervescent and animated. Small things are often considered weaker, more delicate and younger than their larger counterparts. Notice how your eye is drawn to the largest circle, because it is more imposing.

Sizing Up Your Shapes

Mood is affected by the size of forms, shapes and areas of color developed throughout the painting.

sensational color

One of most evocative and expressive tools an artist can use is color. The three properties of color are *hue*, *value* and *intensity*. Each of these characteristics can be employed to influence a specific feeling. Hue is simply the name we give to a color—red, yellow, blue, etc. Value is how light or dark a color is and intensity is how bright or pure the color is.

Color Temperature

Hues can also be described in terms of temperature, warm or cool. The temperature of a color is relative to surrounding hues. On the color wheel, warmer colors, those that lean toward red, appear to advance and feel more aggressive. Cooler hues, those that lean toward blue, recede and are less assertive suggesting a mood of calm or introspection.

"Not all people see or are affected by color in the same way. If they did, everyone's favorite color would be red." Jamie Frayne Kemp

Hue (Chroma)
Hue is the name given to color such as yellow, blue, red or orange. Using a dominance of one hue or family of hues strongly impacts the atmosphere of the art work. For example, blue is generally considered to be tranquil, fresh and calm, whereas red frequently represents excitement, anger, love or stirring passion. Not everyone's emotional interpretation of hues will be consistent because past experiences and cultural background influence their reactions. The color wheel shown here follows the Munsell System and is the basic system for color mixing used by many artists.

Complementary Hues Create Excitement
Hues that are directly opposite on the color wheel are referred to as *complementary colors*. When placed side-by-side, they create excitement as each hue enhances and intensifies the other. If you have trouble remembering the complements think red and green are Christmas, yellow and violet are Easter, and blue and orange are the sky and pumpkins of the Autumn harvest.

Analogous Colors Establish a Harmonious Feeling
Colors that are positioned close to one another on the color wheel establish a feeling of harmony. They are known as *analogous colors*. In this sample you will see the smooth visual transition between neighboring, or analogous, colors.

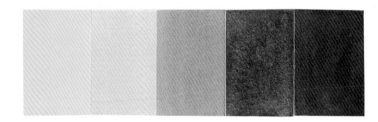

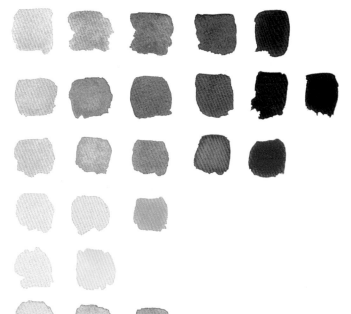

White	High Light	Light	Low Light	Middle Value	High Dark	Dark	Low Dark	Black

Value

The term value is used in painting to indicate how dark or light an area or color is. On a scale, value can be rated as white, high light, light, low light, middle value, high dark, dark, low dark, through to black. Generally light values are perceived as happy or hopeful and provide a feeling of security, while dark values may imply sadness, depression and fear or alternately, comfort or a romantic ambiance. Paintings that are composed of light to middle values are referred to as *high key* and generally emanate a lighthearted, happy, sun-washed feeling. Paintings that range from middle to dark values are referred to as *low key* and often denote melancholy, repose, sorrow or mystery. Strongly contrasting values—extremes of both white and very light against dark values, with few or no middle values—are visually exciting, dramatic and demanding. Subtle shifts in value or a limited value range present a more serene feeling.

Colors Have Value

Value defines more than the range between white and black. It also applies to color. Notice that some hues have a greater range of value. While yellow has a severely restricted range, remaining high in value, violet can extend from light to dark.

Pure Color—High Intensity

The degree of purity of a color is referred to as intensity. Colors are neutralized through the addition of their complement on the color wheel. Intensity is reduced progressively by the addition of increasing amounts of complementary color; the final results being a neutral gray. Clean, pure color is intense and considered joyous, bold and aggressive.

Neutralized Color—Decreased Intensity

When neutralizing the intensity of a color, the aim is to keep the value consistent. Remember, when modifying intensity, the goal is duller not darker. Below the sample of pure yellow, increasing amounts of its complement—violet—have been added. Blue has been mixed with orange, green with red and so on. Less intense color may appear somber, quiet and reserved.

making eloquent marks

Texture and line serve to stimulate the eye and activate the surface of the painting. The quality of the marks produced through the creation of the texture can also further arouse the viewer's sensitivity. Whether the surface texture is created by gentle caressing strokes or wild aggressive attacks of flying paint, the quality and appearance of the marks made expose and convey the artist's inner passions.

Paintings Too Busy?

When exploring the concept of building in the negative, it's easy to get carried away. The process of making hard-edged shapes is addictive and frequently paintings tend to become overly active and extremely intricate. This situation is a natural part of this learning process, but at some point you may wish to calm your work down and provide areas of rest. The best way to deal with excessively busy paintings, and to ensure the presence of some passive areas, is to decide before you begin to allocate only a specific percentage (one-third, for example) of space to active edges, shapes, texture and lines. The remaining balance (two-thirds) will be reserved for quieter passages.

Expressive Lines

Thin or thick, curved or straight, solid or broken, whether produced with a pencil, pen or the stoke of a brush, a line is comprised of a series of moving points that the artist can use to actively direct movement and describe almost anything, including a particular mood. Most certainly a confident, thick brushstroke presents a mood quite unlike a hesitant, delicate pencil line. A subject that is attacked with fervor and loose sweeping brushstrokes will feel energetic and informal.

Precise Lines

A meticulous, precise rendering of the same object appears more cautious, formal and controlled. I am not suggesting that the artist who works in a loose manner is more passionate than the artist that focuses on precision and detail. Rather the comment is directed only to the mood suggested by the quality of the line.

creating diverse textures

Hard, soft, rough or smooth, the textures used in a painting conjure memories of past experiences. Along with describing the characteristic surface quality of an object, a visual textural clue can evoke the tactile sensation of a piece of luxurious fur, the deeply grooved bark of a tree or a shard of broken glass that reminds us of past memories such as bliss, wonder, pain or fear.

When it comes to texture, the surface features of your paper are worth giving a second thought. Rough-surfaced paper is ideal for producing an essence of nostalgia that can be aroused by the coarse textural qualities of age-worn surfaces like barn siding or rusted metal. On the other hand, smooth hot-pressed paper is a natural choice when striving to stir a tender mood as when rendering the delicate, unblemished face of a child.

Combine both lost and found edges, with one type being dominant, to provide information and a road map to areas of interest while encouraging the freedom to explore. Both of the details on this page are from the same painting, *Summer by This Sun*, found on pages 122–123.

Descriptive Edges
Sharply defined edges grab our attention. The eye stops at an edge, follows, then jumps to the next, actively traveling across or around the painting surface. An abundance of hard edges will provide specific details and send an informative message.

Illusive Edges
Soft, undefined, out-of-focus edges are more passive and encourage the imagination to wander. The mind rests and meanders at will, searching for a crisp edge to light on. The lack of descriptive edges will produce a dreamlike atmosphere, encouraging the viewer's personal interpretation.

balance and the division of space — a juggling act

You've seen how shape, size, color, line, texture and edges work to influence the mood of your painting. Now you'll need to distribute these elements in an organized way to create a sense of balance and direct the eye along a visual pathway.

Equal Proportions Are Uninteresting

If you have been to art classes or read books on design, you have most likely been warned against dividing your paper into equal halves or quarters. Although this type of division of space makes for perfect balance and stability, it's just not very interesting if all of the quadrants are the same size and shape.

Shift the Balance

A simple solution is to roughly divide the space into a relationship of two-thirds to one-third. This establishes a more interesting sense of balance. Each shape is a different size and proportion.

A Distance to Travel

A two-thirds to one-third ratio puts greater emphasis on the larger segment of your design. A proportionately larger foreground contributes to the impression of deep space, or distance, and can bestow a feeling of solitude and loneliness. The eye is drawn into the distance.

Up Close and Personal

Increasing the upper quadrant to occupy two-thirds of the painting reduces the feeling of depth. We experience a closer relationship with the subject, as though we are standing inside the picture's plane.

Symmetrical Balance of Elements

For symmetrical, or equal, balance, position identical elements directly across from each other on a format that has been divided into two equal halves. It's easy to balance a painting when you place two equally weighted elements directly opposite each other on the paper. Unfortunately, as with the equal division of space, it's not very interesting.

Asymmetric Balance of Elements

Asymmetrical, or unequal, balance is infinitely more interesting. Elements of different sizes, shapes and colors are positioned in a pleasing manner to provide equilibrium. Color, shape and size each play an active role in affecting balance.

movement and direction—take your viewer on a journey

Just as a map leads a treasure seeker to the reward, you can direct the movement through and around your painting to the areas of interest. You guide the movement with lines—a pathway either real or implied—edges and shapes. This visual movement usually leads to or encloses a chosen area of interest. When the eye is smoothly directed through the painting and experiences a natural balance, the viewer feels at ease and comfortably sat-isfied. Interrupting the movement with imbalance, breaks and barricades can impart a feeling of discomfort.

If the three basic shapes are the circle, triangle and square, it naturally follows that the most basic movements of line are curvilinear, oblique, and straight (either horizontal or vertical). In addition to how and where you want to direct the eye, consider the possible emotional impact that your choice of line can make.

A line or pathway doesn't need to be solid. Even a broken line suggests a continuous movement. An unbroken line, however, moves the viewer's eye at a faster pace than one that is fragmented.

Make It Swing
Just as circular forms feel sensuous and musical, so does curvilinear movement, which naturally swings and flows. The curving red dotted line is a section of the circle that extends beyond the boundaries of the painting. To hold the eye in the painting you might want to provide a secondary curve, the blue circle, to counter the larger arc.

Zig and Zag
To evoke a dynamic and exciting sensation, create a path that darts back and forth, zigging and zagging through the painting in a Z-shaped pattern. The diagonal movement is reminiscent of the triangle and thus provides a similar emotional statement. Soften the impact with a slightly more curving S-shaped path. Diagonal movement takes the viewer rapidly across the artwork. Be careful not to slice the painting into equal halves.

Languid Horizontal Lines
The predominant use of horizontal movement or line evokes a tranquil feeling. A single horizontal establishes a horizon line, while multiples sug-gest the multi-layered strata of the landscape.

Stop the Action
If left unbroken, the eye travels quickly across the painting and out the side (and onto someone else's painting). Provide a few minor verticals to slow or stop the action.

A Heavenly Feeling
Take the eye up with vertical movement to induce a hope-ful, spiritual sen-sation.

Cross Format
Combining hori-zontal with verti-cal movement breaks the sur-face into squares for a design based on the cross format.

Vertical Suspense
A feeling of sus-pense can accompany ver-tical movement, for with only a slight adjust-ment the vertical becomes a threatening falling oblique.

shapes and movement work together to develop a theme

When the focus of your painting is to establish a particular mood, it's natural to partner shape with movement. Combine one type of movement, either curvilinear, oblique or straight, with forms of the same type, based on the corresponding shape—the circle, triangle or square—and you will have a harmonious relationship. The eye moves around the perimeter of a shape in the same way it travels through the painting. The mood established is consistent with the individual personality of forms, lines and movement.

Try a Different Format

When you look at a blank sheet of paper the eye meanders over the surface in search of something to settle on. The direction and pathway that the eye travels is directly influenced by the shape of the paper. So, rather than reaching habitually for a quarter or half sheet of your regular watercolor paper, why not try something different? A support of a new dimension is a very simple step toward establishing a mood-constructed painting and directing eye movement.

Unity Through Shape and Movement

In these three illustrations the shapes were randomly scattered within the space without giving attention to placement. Unity and harmony exists merely because of the association between shapes, line and movements. If the goal is to portray a disturbing experience or provoke agitation, then disunity of shape, chaotic movement and awkward balance help to set the stage.

Curves and circles are compatible with each other. Zigzag and diagonal movements associate well with triangles. A harmonious relationship exists between horizontal and vertical movement and straight-sided forms and lines.

Horizontal Format

A long, narrow horizontal, or landscape format, can contribute to a feeling of peacefulness, stability or solitude. The eye moves from side-to-side, back into the space. Movement from bottom to top is limited.

Vertical Format

Break away from tradition. Why not try a landscape using this format? The same sheet, when positioned vertically in the portrait format, lends itself to a light, airy atmosphere as the spirit soars upward. A feeling of excitement or instability pervades as the tall vertical could easily topple. The eye naturally travels up and down the surface restricting side-to-side movement. The depth of field appears to be shallower, thereby flattening the picture plane.

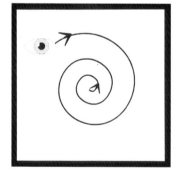

Square Format

All too often overlooked, a square format is a favorite of mine. This stable, perfectly balanced format suggests intimacy—a quiet, captured moment. This format works well for a broad range of viewpoints, from close-up to distant. The eye spirals into and out of the center making the square a powerful window to the artist's private world.

Circular Format

A circle fits into a square format. The feeling is similar, but softened by the rounded corners for a more dreamlike atmosphere. There is no room for peripheral clutter. This format provides a porthole or spyglass view of the artist's innermost feelings and vision.

the center of interest—what to put where

In the theater when only one actor appears on stage, unsupported by props, scenery or other cast, all of our attention is drawn to that individual—the star. He or she is the center of attention. In the same manner, putting one shape of any size, color or form anywhere on a piece of otherwise blank paper immediately draws the eye to that spot. It is clearly the center of interest. There are no other distractions. While a talented actor is able to entertain us and hold our attention, you will most likely want more than just a single shape in your painting. Adding even one additional actor, or shape, begins the competition for attention. If both characters are equally important your attention will bounce back and forth between the two, unsure of where to focus. When taken a step further, filling the stage or picture plane with many actors or forms, all vying for attention, results in a lot of noise and confusion. The stage direction of your painting is up to you. What will be the main attraction and where is the center of interest located?

Take your cue from a battle scene on stage represented in the images on this page. I have simplified the scene to a few basic shapes and values to illustrate the concept. A large cast, all dressed in gray, stands silently around the stage while the two adversaries, in white and black, are embroiled in an exuberant duel, swords waving and crashing. All eyes will be riveted on the two opponents. The area of interest is where the action is. Conflict, sharply pointed shapes, contrast and action are entertaining and demand attention. You will be mildly aware of the gathered crowd; their presence gives support and atmosphere, but there is no doubt what the center of interest is.

Set the Stage
The eye is immediately attracted to the sharp, dynamic triangles with their strong contrasting values (our black and white combatants) and the intersecting lines that represent their swords. Little attention is given to the nonaggressive, softly rounded forms that represent the crowd of bystanders. When compared to the highly active shapes and conflicting values of the swordsmen, these undemanding figures almost disappear due to their close value relationship with the background and their unexciting forms.

Change the Focus
In the previous battle scene, the center of interest is clearly the dueling triangles. Rearrange only the values and notice how our attention is drawn away from the now gray rivals (reduced contrast) to the black and white bystanders. It follows that a wise designer will position highly contrasting elements in choice locations to determine areas of interest.

simultaneous contrast is an attention grabber

When opposites are placed side by side, they enhance and intensify each other. The two equally matched opponents compete for your attention in a phenomenon referred to as *simultaneous contrast*. The eye is captivated by strong contrasts of value, hue and intensity. The greater the contrast, the greater the visual attraction.

Using Contrast

In the past you may have been advised to always place your lightest lights and your darkest darks at your center of interest. While this is a powerful and dramatic way to attract the viewer's attention, there are other, less widely used, options. The contrast of complementary hues can be wildly exciting while the contrasts in intensity are more subtle and elegant.

Contrast of Value

The most eye-catching and demanding application of simultaneous contrast is contrast of value. Step back from this book to see how highly contrasting values (left) are a powerful visual draw when compared to the closer shift in values on the right. Remember that lights appear lighter when surrounded by darks, and darks become increasingly dark when encompassed by light. Contrast of value takes center stage in the illustrations on page 95.

Contrast of Hue—A Vibrant Alternative

Place complementary hues, such as blue against orange, red against green or yellow against violet, to create striking contrasts. The eye bounces back and forth between the two equally demanding hues. Green is enhanced when surrounded with it's complement, red. The same green when surrounded by blue is much less stimulating.

Another very popular alternative is the use of warm and cool colors. This temperature shift enlivens the surface as warm colors advance and cool colors recede setting up a push-pull vibration.

Contrast of Intensity

Pure color appears brighter and cleaner when surrounded by less intense neutrals. There is no need to fear the dreaded passages of mud that we all seem to wallow in. Make use of these neutral gray areas to intensify small areas of pure color. When encompassed by a neutral gray, the green appears clean and vibrant (left). Notice that the same green becomes lackluster when surrounded by a more intense version of green (right).

We view the fight scene once again, but this time the focus is on contrast of intensity. The vibrant pink and yellow seem to glow when set against the neutral backdrop. The muted (low intensity) bystanders blend quietly together with the surroundings.

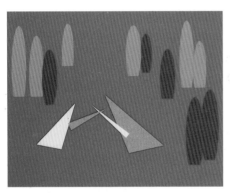

Focus on Hue

This vibrant and exciting depiction of the battle scene is based on a contrast of hues. The yellow and orange are striking when played against the bright blue background, while the violet and green figures, with their closer relationship to blue on the color wheel, are not as competitive.

action speaks louder than words

In addition to using contrast for attracting attention when establishing areas of interest, an entertaining option is the use of high activity and intricate details. The eye hunts for interest—crisp edges, highly textured surfaces, patterns and intersecting lines—in preference over lost edges and quiet passive passages. The more you weave shapes and lines, create texture, and enhance the surface, the more mesmerizing these areas become, but only up to a point. There can be too much of a good thing. For just as a stage full of actors each shouting his own story makes for a lot of confusion, so too does an overly active painting. Patterns, textures and intricate details are exceptional devices for holding the viewer's attention when used judiciously, so consider carefully how much and where best to place them.

Where you position shapes and the centers of interest in your painting goes beyond simply making a pleasing arrangement. Theater directors and advertisers know that certain positions on the stage, or on advertising layouts, demand the most attention. Frequently underestimated, placement is a powerful design tool that can immediately influence the aura of the work. Placement also affects the sense of balance and directs movement throughout the work. If the shapes and areas of interest are placed haphazardly or in conflict with each other, or if the artist has not provided a satisfying balance of elements, the results will leave the viewer agitated and unsatisfied.

Select Your Design Tactic

When establishing areas of interest, the list of attention-seeking devices are:

- simultaneous contrast of hue—(complementary or temperature), value or intensity
- textures
- intersecting lines
- hard edges
- vibrant color
- highly intricate detailing

If you are wondering how you can possibly combine all of these into a single painting, you'll be relieved to know that you don't have to. In fact, cramming every device into one painting will cause chaos and defeat your purpose. Say one thing well by selecting one type of simultaneous contrast, either hue, value or intensity, as the major player. A minor supportive role can be taken by one or two of the remaining tactics.

Color Stands Alone
There is no doubt about it: the eye loves color and actively seeks it out. If you want to attract attention, wave a brightly colored flag. A dull, or lightly tinted one just won't have the same effect. Pure color is captivating and electrifying. Position your cleanest, most vibrant color with the knowledge that you will be announcing "Look here!" Notice how the flags of pure color are the most eye-catching.

Mass Confusion
Whether it's a stage full of battling actors or a painting filled will too many equally demanding elements, the overall effect is clutter and confusion.

the importance of closure

When your eye sees identical shapes or colors, the mind registers the relationship and connects them together. This is referred to as *closure*. Closure directs the movement around the painting, holds the viewer's eye within the painting and establishes balance.

The closer the relationship between the elements, the more apparent the connection and resulting sense of closure.

Allow your search to continue and you will discover other visual relationships.

To lesser degrees closure is generated by the association between components that are similar, such as hues closely situated on the color wheel—the relationship between red-violet, red and blue-violet.

Other options for producing this effect include the repetition of one hue using different values, such as a light, middle and deep violet, or the multiple use of a single shape in a variety of hues or sizes.

For painters this means that it is possible to adjust the balance and movement of our art work by the repeated use and thoughtful positioning of elements of like color, shape and size.

The Eye Moves From One Point to Another
Two common elements are connected with a straight line.

Creating an Enclosed Shape
The simplest enclosed form you can make is a triangle. It requires only three dots or three related elements.

Searching for Related Elements
As you scan through the shapes and colors in this illustration, your eye connects the three identical blue circles to form a triangle. Identical elements have the strongest relationship and provide the most obvious example of closure. The triangular shapes are connected by their shape. The red and pink colors unite these various shapes through their common hue, although different in value.

a juggling act—placing your center of interest

The easiest way to determine where to place your areas of interest is to juggle a few shapes. There are undoubtedly times when you will only want one area of interest, but to establish an appealing sense of balance and provide closure, plan on establishing three areas: the main center of interest, a lesser or secondary interest and a minor point of balance. Cut a large, a medium and a small circle out of a piece of scrap paper. These paper cutouts will represent the key actors or centers of interest. Shift and rearrange the circles on your watercolor paper to establish a pleasing balance. The circles will form the corner points of a triangle; this is closure at work. There is no right or wrong to which size goes where, only consequences. Once you have achieved a satisfying arrangement of paper circles, thereby determining where your three centers of interest will be located, you will need to take into consideration how shape, color, size, texture and line will impact on the design. Assembling different combinations of these qualities provide endless possibilities for balancing elements.

Caught in the Middle
Positioning the primary focus directly in the center of your paper breaks the remaining space into uninteresting, equal sections. The center of the painting is a visual magnet that tends to trap the viewer, making it difficult to explore and enjoy the rest of the painting.

A Position of Stability and Weight
When major shapes and areas of interest occupy the lower quadrant, they appear heavier and exude a rooted, stable attitude. Forms located in the lower quadrant appear to advance.

Position of Freedom, Flight and Power
If you want to put greater emphasis on a particular thing, try placing it in the upper portion of the painting. Objects in this location appear heavenly, happy, spiritual or powerful. As a shape is positioned higher on the picture plane, it appears to move back in space to suggest distance.

Which Composition Is Right?
There isn't an absolute right or wrong, but certainly some configurations are better than others when it comes to presenting a particular mood or atmosphere. A great way to learn firsthand about design is to arrange and rearrange the individual components in your paintings to see how a simple manipulation or tiny adjustment can make a big difference.

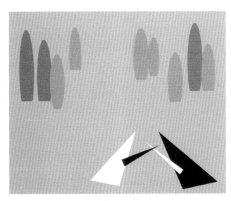

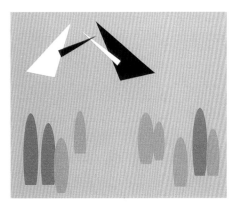

Shifting the Area of Interest
Here are our dynamic duelers at it again. Notice how a change in the placement of the elements affects the mood of the scene. When the center of interest is placed low, you view the action from close-up. In your position as an onlooker, you are placed within the scene. The crowd appears in the distance and are watching the fight, face forward.

Place the focus in the upper portion and, although the action moves further away as the sense of distance breaks the intimate connection, the battle is imposing. Due to its lofty position on the picture plane we raise our eyes up to the contrasting figures. The neutral bystanders, now in the lower position, are fixed to the spot and act as a barrier, separating us from the action. In order to see the fight they appear to have turned their backs on us. Notice how even their tall pointed shapes lead to the area of interest.

creating variety by repeating elements

The repetition of design elements provides a clear message as to the artistic intent, establishes mood and rhythm, provides harmony and, most importantly, unifies the painting. Repeat yourself too many times, whether in a conversation or a painting, and you are likely to hear "I'm bored, I've heard/seen this already." Constructing a painting with a limited number of repeating components doesn't have to be restrictive or boring if you provide a little variety. In order to make your concept crystal clear and yet maintain interest and entertain the viewer, the repeated elements need only to be similar not identical. Variety can be achieved through the gradation, alternation and contrast of elements.

When repeating shapes, you should limit yourself to using just two or three of the following options described. If you attempt to employ all these elements for variety in one painting, you'll undermine your efforts to achieve unity.

A Single Shape
Begin with a simple shape that represents the object you wish to suggest. The next step is to repeat that shape several times in a variety of ways by changing the hue, value, intensity, size, placement, direction or texture of the shape.

Repetition—A Chorus Line of Shapes
The identical shape is repeated eight times. When repeated without any variation, the design becomes monotonous.

Variety in Hue
The hue of the leaf shape is changed from green to yellow, then orange, red, violet and blue. Only the hue has been changed, not the value or intensity.

Variety in Value
The progression of value changes from light to dark. You can create even more variety by shifting the values of the shapes in a random manner.

Variety in Intensity
The color of the first leaf is clean and intense, but the subsequent leaves drop in intensity. The color becomes dirtier due to the addition of its complement, in this case, red.

Variety in Size
Larger shapes suggest growth and are generally more imposing and demand more attention than smaller ones. Dissimilar sizes can also suggest distance. Size can shift the balance of your painting; it may take two or three small items to balance a single large one.

Variety in Placement
The spaces between the shapes can become as important to the overall design as the leaf shape itself. Variety is achieved by adjusting the size of the surrounding spaces and also by overlapping the shapes.

Variety in Direction
The viewer's eye moves around the painting according to the direction of the shapes. In this sample the changing angles of the leaf shape create movement and activity. The last two shapes have been turned upside down or flipped to a mirror image.

Change Within a Shape
Variety may also be incorporated within the individual shape. Gradual transition within the shape is referred to as gradation. It can apply to all of these elements but is most often used with color. The value may evolve from light to dark, the hue from green to orange, or the intensity from clean to sullied. The transition in texture can be smooth to rough, or from hard to soft.

assembling the pieces

The essential roles that each of the elements of design play, when portraying a particular mood, seem logical when taken one chunk at a time, as in the preceding pages of this chapter. The contributions that the principles of balance, direction and movement make, as well as the placement of areas of interest, have been broken down and analyzed.

You have seen a variety of effective ways to create areas of interest through simultaneous contrast, engaging color, intersecting lines and active passages. It all seems like common sense when playing with little circles and dueling triangles, but when it comes to applying all of this information to an actual painting you might consider the whole thing a little too abstract. After all, you probably want to paint more than just circles, squares and triangles. The good news is that you can apply these simple design concepts to anything and everything you wish to paint. You can still paint daisies or the old mill, but let the choice of a mood guide the decision-making process when planning your overall composition. It's simply a matter of following a step-by-step plan while incorporating a few mood-enhancing adjustments.

Picture Planning Worksheet

Photocopy the worksheet on page 125 and complete it to make picture planning easy. You don't need to be a slave to the list, nor do you need to fill in every blank; it's a guideline only. It's perfectly acceptable if a few opposing ideas creep into your painting. Just be sure to balance a predominance of elements that convey your message with a subordinate amount of conflicting (contrasting) components. You'll be surprised how easy it is to make your choices.

There is no "one way only," because your interpretation of any particular mood will be different from someone else's. Just go with your gut instinct. Once you have the worksheet filled in keep it close by to refer to while you develop your painting.

Spring Landscape in Watercolor

The arrival of the long-awaited spring is cause for celebration. Fresh, clean reds and oranges are loosely applied, wet-into-wet, with diagonal strokes. Cool blues are brushed on juxtaposing the predominantly warm hues. The shapes remain soft and ambiguous, while hints of pure color and light rim the edges hinting at tree forms. Minimal development and definition is required, for rather than documenting a certain place or group of trees, I chose to portray the memory of a balmy, blossom-filled day.

Watercolor • 11" × 11" (28cm × 28cm)
Collection of Anthony Batten

putting the plan into action

Using the simplified plan on page 125, I have painted a cluster of leaves that grow in the woods just outside of my studio window. The leaves in both paintings are similar in shape, but with minor modifications. The variations between the paintings are striking essentially because of the different mood that is expressed by each piece.

A final note regarding the complexity of design: It's essential to recognize that each individual piece (element) of the painting does not exist solely on its own, but in combination with all the other components. The parts interact and relate to each other, altering and influencing the overall effect. The design becomes more complex as each new element is added. The combinations of components are infinite, providing challenge and reward to the creative spirit.

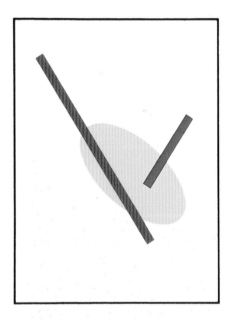

A Plan for Excitement

The feeling of excitement, not leaves, is the subject of the painting. With this in mind, here is my plan:

Format: narrow, vertical

Shapes: angular, pointed

Size: combination of large (aggressive) and small (effervescent)

Colors: pure, intense hues—no dull color

Value range: white to very dark—very few middle values

Lines (brushwork): bold and explosive—generated in an upward movement

Texture: created in an exciting way such as spatters and random splattering of paint

Edges: crisp and sharp

Movement: diagonal (primary shown in red, counterbalance shown in blue)

Placement of area of interest: high (marked in bright yellow)

Interest created by: simultaneous contrast of values (major) and hue against complementary hue (minor)

AN EXPRESSION OF EXCITEMENT
Watercolor
6" × 8" (15cm x 20cm)

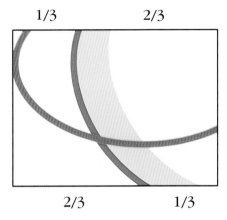

1/3 2/3

2/3 1/3

A Plan for Serenity

The same branch of leaves is depicted, but this time the subject is a serene mood. To reinforce this mood I developed this plan:

Format: long horizontal

Shapes: rounded—soften sharply peaked triangles

Sizes: medium—noncompetitive

Colors: cool blues, violet and green

Value range: middle values to dark—no white

Lines (brushwork): produced in a gentle flowing manner, nonaggressive

Texture: minimal

Edges: soft and lost—crisp in area of interest

Movement: curvilinear (red) counterbalance (blue) by curving shape of area of interest

Placement of area of interest: arc (yellow) through one-third top, two-thirds bottom

Interest created by: small intricate pattern of light, the balance of the painting will remain passive

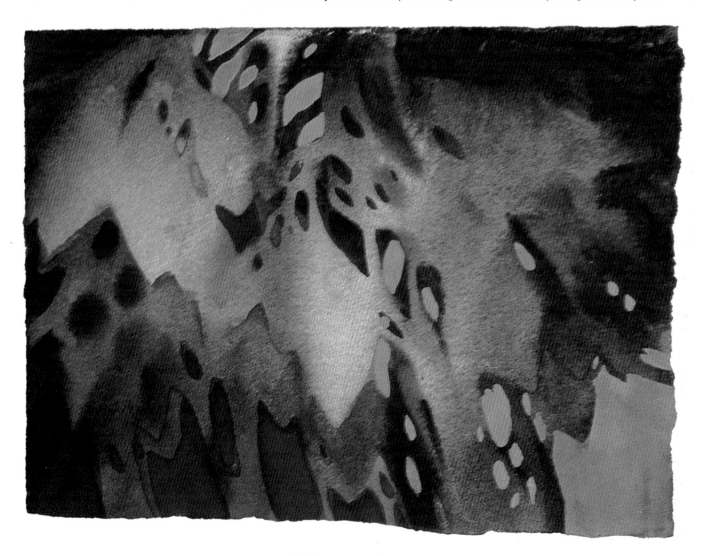

AN EXPRESSION OF SERENITY
Watercolor
8" × 6 " (20cm x 15cm)

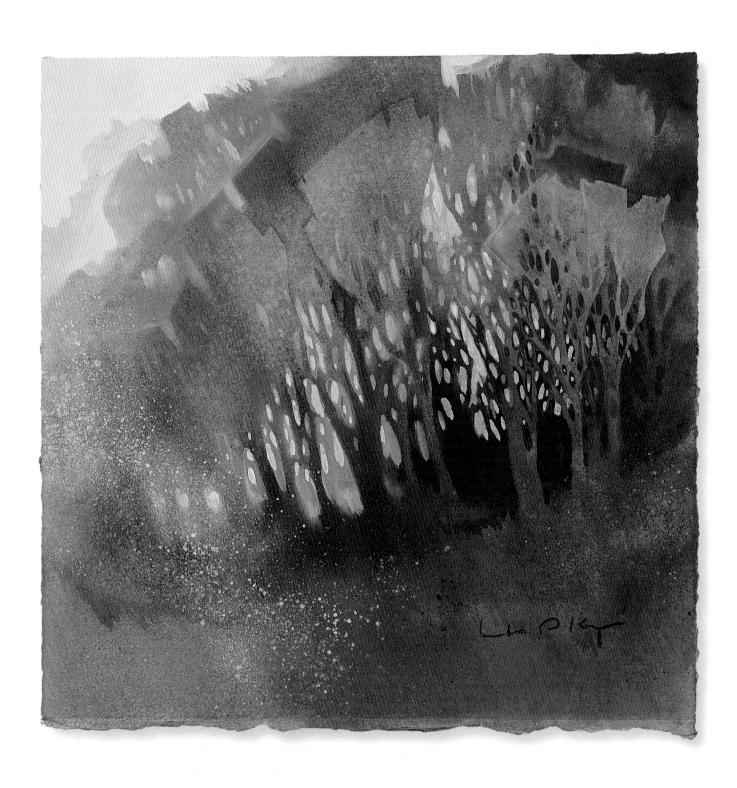

ROCKWAY, MORNING LIGHT—LANDSCAPE MIRAGE SERIES
Mixed water media
11" × 11" (28cm x 28cm)

assembling
the pieces of the puzzle

It's time to put all of the pieces of the puzzle together. In this section you will follow along with demonstrations of three different subjects. All are developed by building layers of negative shapes and glazing. Each painting begins using the worksheet found on page 125 and a planned underpainting that reflects my interpretation of the selected moods. Of course you are free to choose to represent them with your own artistic translation. The subjects evolve following the lessons found throughout the earlier chapters. You will notice that I haven't predrawn any of my shapes, but don't let that worry you. You certainly may sketch as you go. With the exception of a few calligraphic twigs in the first demonstration, all of the shapes are made using the negative approach. In order to reinforce this new shift in the way you think and work, you need to resist that old temptation of going back into shapes to add details, textures and shadows or to model forms. Remember to dry the paper thoroughly between each layer when glazing.

While the demonstrations are intended to lead you step by step through the stages, it is essential to recognize that the fluid nature of watercolor seems to have a will of its own. It's this unpredictable nature that makes this medium so exciting and exquisite. Keep an open mind and react to what is happening on your paper rather than trying to exactly duplicate the illustrated painting.

To help you work through all the stages in the development of a painting, no matter what the subject, follow the same course of action.

- **Consider** the goal and purpose of the painting.

- **Determine a plan** for the overall design, balance, movement and format, and decide on areas of interest and areas of rest. Select colors that will create the desired mood and light conditions.

- **Establish an expressive underpainting** following the planned guidelines.

- **Create simple shapes and repeat them** using variety of size, color, placement and direction.

- **Develop layers** from front to back or bottom to top.

- **Evaluate** the effectiveness of the design, color choices, shapes and harmony of all the elements. Have you achieved your goal?

- **Adjust** any elements that are out of tune.

- **Celebrate** your accomplishments. Achieving perfection is not necessary. The final painting may not be exactly what you had originally planned. It may, in fact, have evolved into something quite different, yet unique and wonderful. Remember, *stay flexible*. You are the director. Be open to creative impulses and opportunities.

layering floral shapes: painting the spirit of joy

The goal of this painting is to paint an expression of joy. The particular kind of flowers depicted isn' t important—in fact they can be from your imagination—just as long as the forms and colors convey a joyous sentiment. This painting accentuates contrasts of complementary hue as well as value change.

supplies

8" x 22" (20cm x 56cm) sheet of 140-lb. (300gsm) or heavier cold-pressed watercolor paper

1-inch (25mm) soft flat brush

1½-inch (38mm) soft flat brush

No. 10 round sable or sable mix brush

Cadmium Orange

Cerulean Blue

Cobalt Blue

Leaf Green (yellow-green)

Quinacridone Violet

Format and Plot Plan

Movement (red line)— zigzag, exploding upward from bottom to top.

Areas of interest (yellow, in order of importance)—main interest placed high on the picture plane encourages the eye to travel up.

Planning for Joy

Format: narrow, vertical

Shapes: angular

Size of shapes: large to small

Colors: rich and bright—no dull or dirty color

Value: range will be from white to dark—no black—with clean pure hues in dark areas

Brushwork: aggressive and bold, diagonal strokes

Texture: splashes, splotches and spatters

Edges: hard, crisp defined edges in areas of interest, slightly softer in less important zones

Activity level: two-thirds active, one-third passive

Balance and division of space: focus on upper two-thirds for an uplifting feeling

Attention seeking devices (what to put in the areas of interest): primary—contrast of hue; secondary—contrast of value; intricate and active shapes

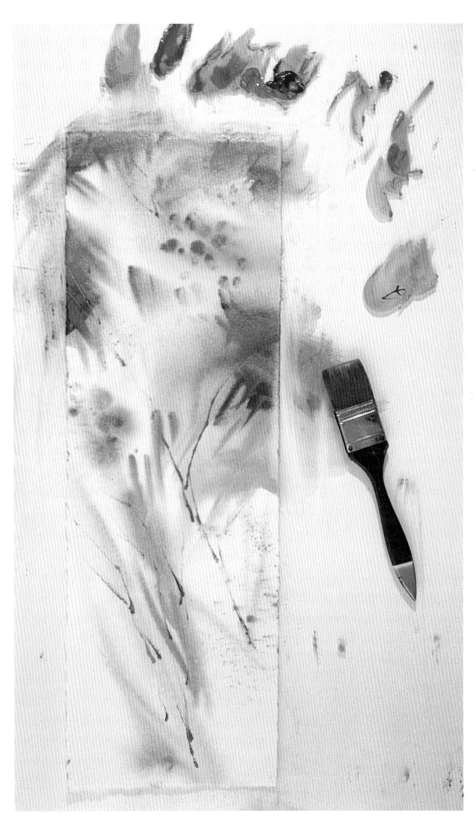

1 ESTABLISH THE UNDERPAINTING WITH BRIGHT COLORS AND BIG BRUSHSTROKES

Saturate the front and back of the paper with water (see page 26 for wet-into-wet under-paintings). Lay out fresh mounds of paint on a clean palette or the top edge of your Plexiglas. Using the plot plan as a guide, prepare a wet-into-wet underpainting with upward, energetic strokes of pure blue and green mixtures. Using the 1½-inch (38mm) soft flat, follow the pre-determined line of movement with large gestural swings of the arm. Remember to double dip. Work boldly and don't hold back. Allow the brushstrokes to extend beyond the boundaries of the paper. With the no. 10 round drop juicy dollops of Cadmium Orange and Quinacridone Violet into the main (1) and secondary (2) areas of interest. Splatter this combination lightly in the remaining point of balance (3). Lift and tilt the paper to encourage the color to flow across the wet surface. Spatter and dash strokes of clean blue and green up the surface.

As the paper begins to dry and lose its shine, you will notice that the paint no longer disperses wildly across the surface. Now is the time to begin working with more control (see page 31, heavy on damp). Use the 1½-inch (38mm) soft flat and undiluted combinations of blue and green paint, to carve around long, angular, negative leaf forms. To suggest twigs, apply calligraphic marks with thick paint applied with the pointed wooden end of the round brush. These are the only positive forms. Place the completed damp foundation on a wooden board to dry completely.

When painting the *Essence of Joy* you won't go wrong using pure color, angular shapes and upward movement.

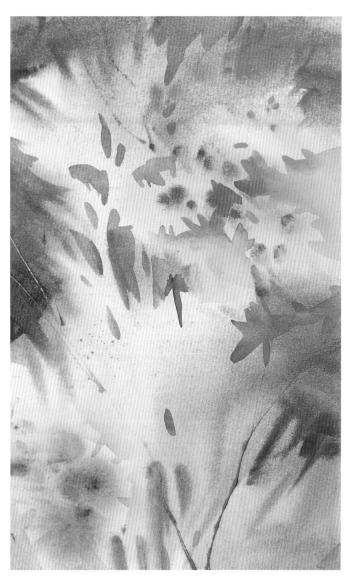

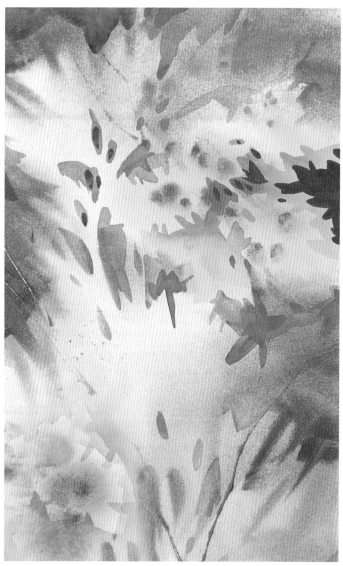

2 CREATE SIMPLE SHAPES WITH VIBRANT COLOR

In the main and secondary areas of interest
(1 and 2) begin to carve around the first layer of
flowers using rich glazes of orange and red. Cut
away at the shapes with the 1-inch (25mm) flat
on dry paper to keep the edges crisp and to
exaggerate the angular forms. Continue to
work in the negative, and begin to delineate
large leaves and main branches with trans-
parent glazes of blues and greens. Allow the
painting to dry.

3 REPEAT THE SHAPES TO BUILD FLORAL FORMS

Carve around a second layer of blossoms in the
main area (1) with rich Cobalt Blue for a vibrant
contrast of hues. If the blue is thinned with too
much water, it will be neutralized by the under-
lying orange. In the secondary area of interest
(2) apply a third glaze of diluted orange to
build additional layers of floral shapes. This
gradual transition of hues will support the pri-
mary focal area, but not detract from it. Con-
tinue to mold leaves in the upper two-thirds of
the painting using progressively darker values
of green and blue. Add the small negative
shapes of air holes between the branches and
leaves with a no. 10 round.

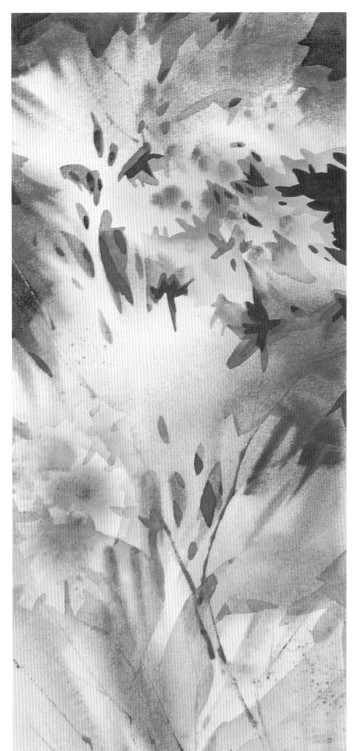

4 CONTINUE TO BUILD LAYERS

Continue to sculpt the clusters of flowers in the upper area of interest using pure orange and red. Dry these hot colors completely before laying in more deep blue to ensure sharp edges and to avoid sullying the color. Work around the painting to develop multiple layers of leaves and stems. Follow the main line of stems to ensure a natural connection. Make sure the stems line up.

5 DEVELOP THE MINOR AREA OF INTEREST

Develop smaller, less intricate blossoms with little change in value or hue in the areas of the orange splatters. Move down the paper to the point-of-balance area (3) and begin to develop a few overlapping leaves. Keep the changes of hue and value subtle by glazing with delicate tints, or wash excess color away. While the wedgelike shapes are repetitive, slightly softer edges and more gradual transitions of color and value provide variety.

Place clean, dark blue against light or white areas to provide contrast of value. Create contrast of hue by abutting bright blue with its complement, orange.

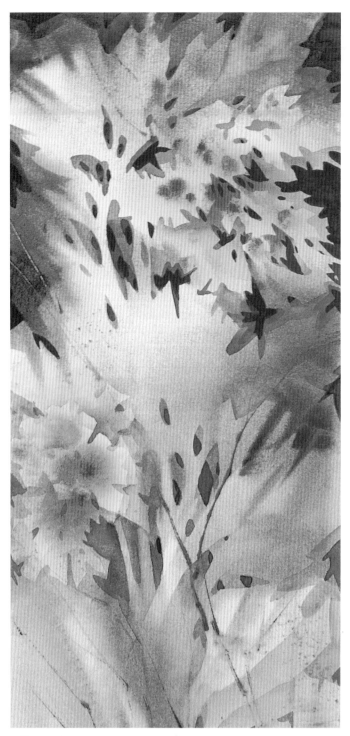

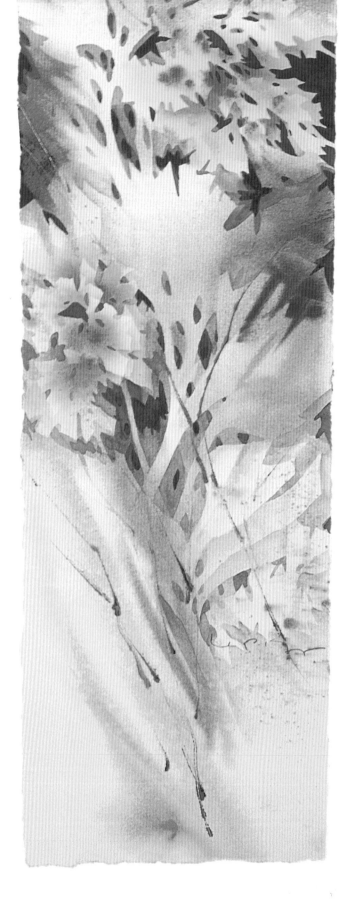

6 BALANCE THE DESIGN

Stand back from the work to evaluate the overall balance and movement of the painting. Make final adjustments of awkward shapes, distracting lines and out-of-tune elements. Lift any areas of dull color with a soft wet brush and a tissue, then repaint with clean hues.

CELEBRATE AN EXPRESSION OF JOY
8" × 22" (20cm x 56cm)

lifting and tinting: swept away

Have you ever been swept away; caught up in a moment of rapture? Perhaps you were enthralled by a moving passage of music or taken by the glimmer of sunlight as it streamed through an otherwise gray day. Capturing that heavenly instant of bliss on paper is certainly a daunting challenge.

Up to this point in the book most of the layers have developed from light to dark. In this demonstration you will learn how to bring back the light through lifting and tinting. The most striking use of contrast in this painting is that of value—darks and lights opposing each other—supported by contrast of intensity.

supplies

11" x 11" (28cm x 28cm) 140-lb. (300gsm) or heavier cold-pressed watercolor paper

Burnt Sienna

Cerulean Blue

Phthalo Blue

Phthalo Green

Quinacridone Violet

Raw Sienna

1-inch (25mm) or 1½-inch (38mm) soft flat brush

Nos. 10 and 12 round sable or sable mix brushes

Small bristle brush (a clean oil painting brush works well)

Facial tissues

Format and Plot Plan

Movement (red line primary)—strong sweeping curve (blue line secondary) repeat and balance.

Areas of interest (yellow, coded in order of importance)—triangle of areas (1, 2 and 3) balance high to middle of picture plane. The shape of the areas of interest needs to follow the direction of movement.

A Plan to Sweep You Away

Format: square

Shapes: sensual curves combined with long angular forms

Size of shapes: small—medium

Colors: muted neutrals and smaller areas of clean tints

Value: full range from white to very dark

Brushwork: soft and flowing

Texture: minimal

Edges: lots of soft and lost edges, any defined edges reserved for areas of interest

Activity level: two-thirds active, one-third passive

Balance and division of space: focus on upper two-thirds

Attention seeking devices (what to put in the areas of interest): contrast of value and contrast of intensity—clean tints against neutrals

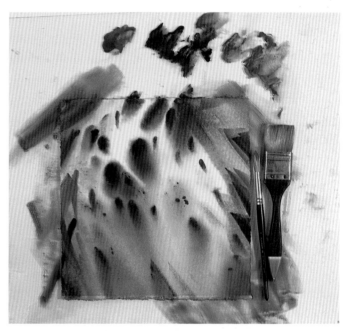

1 ESTABLISHING AN UNDERPAINTING

Dispense a generous quantity of fresh paint. Prepare the paper for a wet-into-wet underpainting. Scoop into the Phthalo Blue, Phthalo Green and Burnt Sienna with a no. 12 round. Fold the colors together on a clean palette with very little water, but don't over mix. Press a few brush loads of the rich, dark color onto the saturated paper. In areas (1) and (2) apply a delicate blush of Burnt Sienna and Quinacridone Violet. While reserving several areas of white paper in the upper quadrant, with a soft, 1½-inch (38mm) flat, sweep combinations of Cerulean Blue, Burnt Sienna and Raw Sienna in a gently curving arc following the planned lines of movement from top to bottom. Reload the brush after every few strokes. When the paint no longer flows and spreads, delineate negative leaves with heavy strokes of Cerulean Blue and Burnt Sienna using the heavy on damp technique (page 31). Dry your underpainting on a flat wooden board.

2 CREATE SIMPLE SHAPES AND BUILD IN THE AREAS OF INTEREST

Glaze around the first set of berries in areas (1) and (2) with Burnt Sienna and Quinacridone Violet. Use a no. 10 or 12 round to dilute and wash color away from the clusters. Establish and modify leaf forms and stems with well-diluted Cerulean Blue and Burnt Sienna.

3 DEVELOP MULTIPLE LAYERS WITH REPEATED SHAPES

When the previous layer is dry, tuck a second set of berries behind the upper layer with a medium value of Burnt Sienna and Quina-cridone Violet. Be sure to include tiny negative holes and slender stems. To provide visual flow, glaze around branches in this area with some of this warm color combination.

4 LIFT COLOR IN THE NEGATIVE SPACES

To create a backlit effect and the flicker of light and to establish dark branches, lift color from extremely dark areas with a wet, stiff scrubbing brush. Gently work the bristles back and forth over a small area, then blot with a dry tissue to pick up the softened paint. You won't retrieve bright white paper, but due to the simultane-ous contrast, the pattern produced will be sig-nificantly lighter than the surrounding darks.

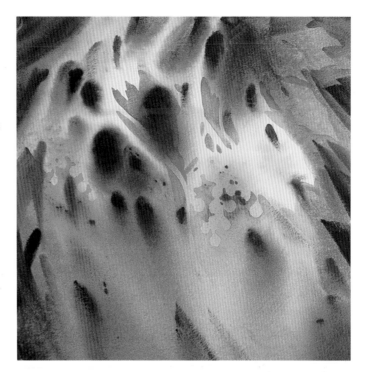

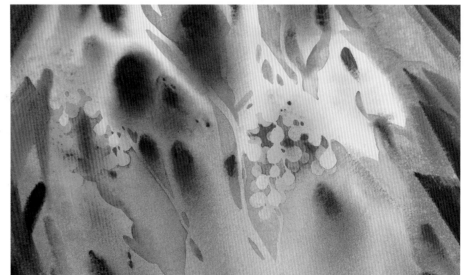

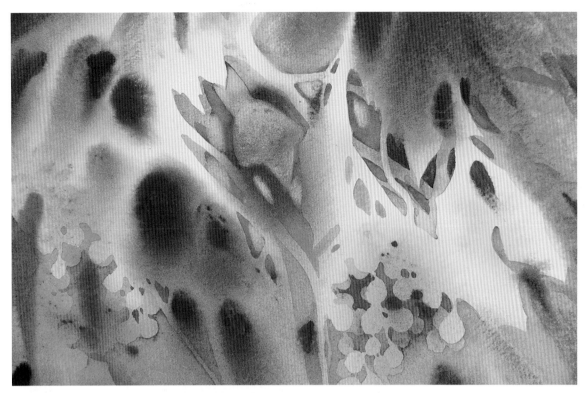

5 CREATE NATURAL SHAPES

Continue to lift patches of light to delineate branches and leaves in the dark and neutral areas. Aim for dissimilar shapes and sizes in these negative shapes.

6 DROP COLOR INTO THE LIFTED AREAS

Dry the negative holes. Using a no. 10 round, glaze over them with a thin vibrant mixture of Burnt Sienna and Quinacridone Violet.

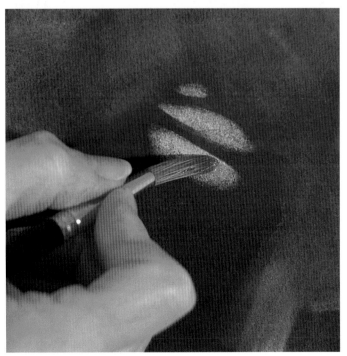

Get swept away by remembering to use big swinging brush strokes and to play lights against darks.

Create Unity

Compare this close-up with step five. The delicate rose-colored glow establishes a connection with the red berries as the warm light appears to emanate from behind.

Work to establish unity through repetition of color and shape (closure) throughout the painting process.

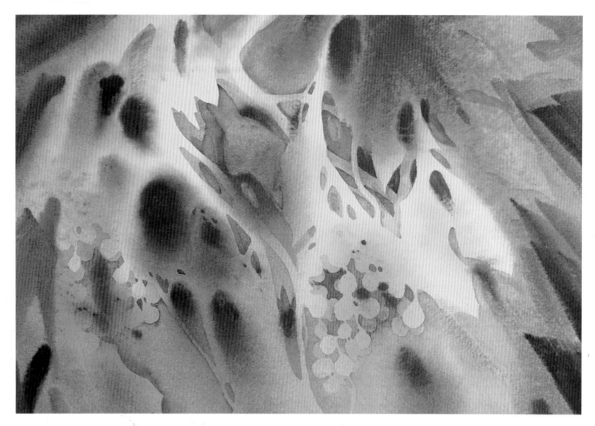

7 WEAVE SOME BRANCHES

Work in some leaves and weave negative tendrils of branches that follow the desired swing of movement—the red and blue lines on the plot plan—with darker and duller layers of glaze.

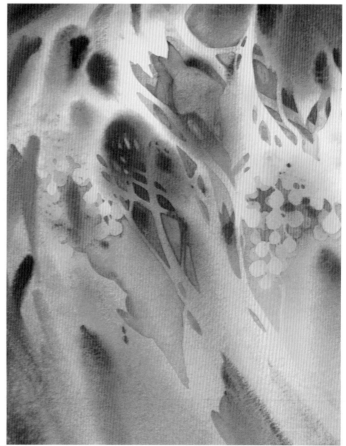

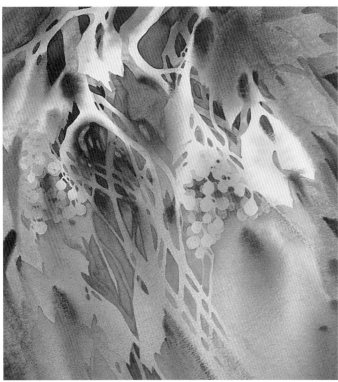

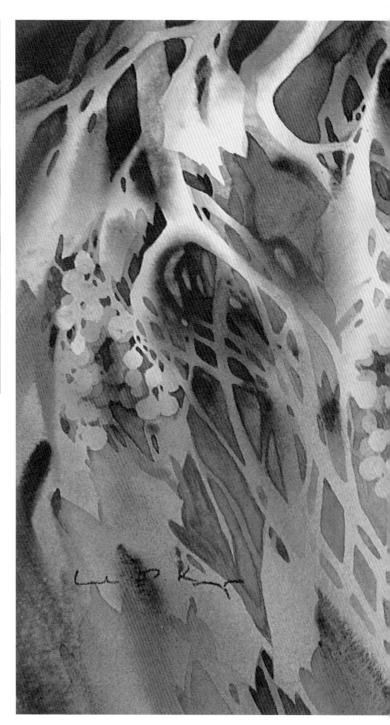

8 ADJUST AWKWARD SHAPES
Paint around a third set of berries with dark Burnt Sienna and Phthalo Blue. Form the berries with careful attention to the small negative spaces. Scan the stems and large branches. Do they make sense? Trim any that are clumsy or overly massive by glazing over or lifting out. Define and adjust nonspecific and poor shapes within the areas of interest. Shapes that are beyond these areas may remain somewhat vague.

9 FINE-TUNE THE BALANCE
Stand back to check the overall balance of your work or look at it in a mirror. Does the work have an elegant flow or does it look like it might topple over? Have you provided a repetition of similar elements (color, shapes, lines) to form triangles and provide closure? Frequently a few minor adjustments are all that are needed. Lift and tint any overly dark areas that appear to block the passage of light or weigh the painting down. Warm up raw areas of white that are distracting or take the eye out of the painting with a well-thinned combination of Burnt Sienna and Quinacridone Violet or cool them with Cerulean Blue.

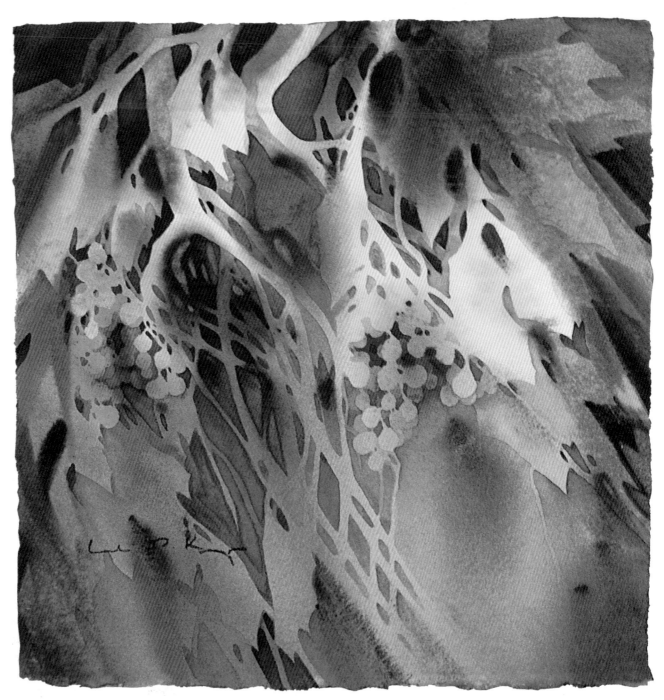

SWEPT AWAY
Watercolor
11"× 11" (28cm x 28cm)
Private collection

capturing a mood: finding solace–the great escape

Travel to a place beyond a field of softly blowing grasses and past the trees. Take a journey to a place that soothes the soul. Whether you find your solace within the sheltered walls of a sanctuary, a private place in the woods or just sipping a cup of hot tea, you look forward to a few moments of quiet repose when life gets a little too hectic, if you're like me. Expressing this passage into tranquillity in words may lead to eloquent poetry, capturing this state of being with paint and paper will be the desired destination for this painting.

supplies

11" x 8" (28cm x 20cm) 140-lb. (300gsm) or heavier cold-pressed watercolor paper

1-inch (25mm) stiff bristle brush

Nos. 8 and 10 round sables or sable mix brushes

Burnt Sienna

Cerulean Blue

Quinacridone Violet

Raw Sienna

Soft Pastels: Pale tints of blue, pink and gold

Blending stump

Acrylic Gouache: Holbein Ivory White or Pale Peach—this exceptional, versatile product dries with a matte finish and can be mixed or glazed over with watercolor

Format and Plot Plan

Movement (red line primary)—horizontal rolling lines.

Areas of interest (yellow), in the order of importance 1, 2 and 3—triangle of areas. Main area of interest (1) high on picture plane to take the eye up and back. The shape of the areas of interest should follow the direction of movement.

Mapping Out a Plan for Describing Solace

Format: long horizontal

Shapes: horizontal (reclining) sensual curves

Size of shapes: small-to-medium; build overlapping layers to suggest distance

Colors: muted neutrals and smaller areas of clean tints—naturalistic color

Value: limited range—light to middle value, very little dark, no white, no black

Texture and brushwork: drybrush texture on damp paper—melt crisp to diffused—softly texturize surface to suggest blowing grasses and sunlight sparkles

Edges: soft and lost, any defined edges reserved for areas of interest

Activity level: one-third active, two-thirds passive

Balance and division of space: focus on upper two-thirds

Attention seeking devices (what to put in the areas of interest): contrast of intensity with minimal contrast of value; intricate detailing restricted to areas of interest

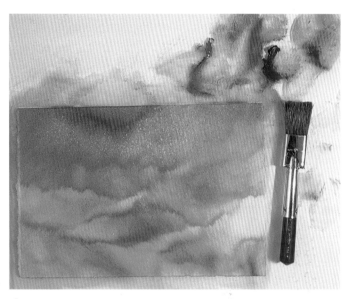

1 BUILD A DRY-INTO-WET UNDERPAINTING

Lay out a generous quantity of Cerulean Blue and Raw Sienna, and smaller portions of Burnt Sienna and Quinacridone Violet. Dampen both sides of your paper and create a dry-into-wet underpainting (see page 29) using the 1-inch (25mm) stiff bristle brush. Work heavy, undiluted paint into the fibers of the brush and apply with short, choppy, downward strokes. Change the angle of your brush frequently to suggest blowing grasses. Vary the color, width and direction as you lay in the horizontal, rolling bands from the bottom to the top of the paper. Brush clean tints of pink and gold into the two lower areas of interest (2 and 3). Don't wash your brush or add a lot of water or you'll end up with a soggy mess. To change color, rub the dirty bristle brush on heavy toweling and then reload with clean color. To add sparkle, apply a light misting of water over the damp paint, or spatter with clean color. Dry on a wooden board.

2 ESTABLISH SIMPLE, DESCRIPTIVE SHAPES IN THE FOREGROUND

Define the first layer of negative grasses and small shrubs in the foreground with a no. 8 round. Pull the front row forward by glazing behind it with a middle value glaze of Cerulean Blue and Burnt Sienna. Good descriptive edges are the goal. You are not painting grass and shrubs, you are painting around and behind them. If the neutral color appears dull and heavy, wash it upward with plenty of water.

3 BUILD MULTIPLE LAYERS TO CREATE A RIM OF PURE COLOR

Cut progressive tiers of distinctive grass edges in the lower areas of interest using your no. 10 round. Use the rich gold of pure Raw Sienna, and a fresh, vibrant Cerulean Blue, or a clear pink or violet that has been made with Cerulean Blue and Quinacridone Violet. Delineate a crisp rim of glowing color, then wash the excess away.

4 CUT AROUND TREE FORMS

Block around the top edge of the first cluster of trees in the upper-most middle of the painting with Burnt Sienna to which a small amount of Cerulean Blue has been mixed. Sculpt around a few willowy trunks and lower branches.

In this painting, to conjure an atmosphere of a solace remind yourself to play clean tints against neutral color and establish soft, rolling, horizontal layers.

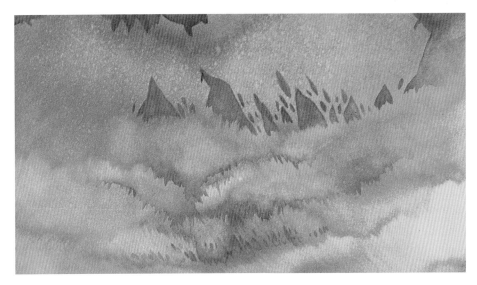

5 ESTABLISH DESCRIPTIVE TREE SHAPES

Extend the top of the tree line across the width of the painting. Using a round brush, continue to pare away at the trunks and main branches with a light to middle value mix of Burnt Sienna and Cerulean Blue. Be sure to vary the spacing, shape and size of the trees and negative spaces. Leave a few clusters of trees as one large clump rather than dissecting every mass into individual trees.

6 SPACES WITHIN SPACES

Use a no. 8 round loaded with a darker, heavy-bodied blend of Burnt Sienna and Cerulean Blue to tuck a second layer of trees into the negative spaces created by the previous layer.

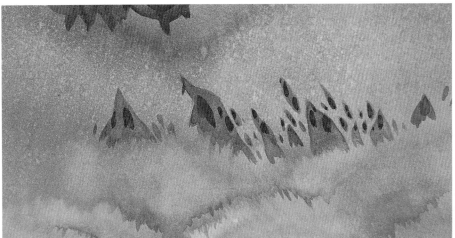

7 EMBELLISH WITH FILAGREE

In the main area of interest (1), work around the network of branches with deep rich color. Shift back and forth between the layers to carve interesting and imaginative tree forms. Push and pull the layers by glazing around the shapes. Use the darkest color and sharpest edges in the focal area.

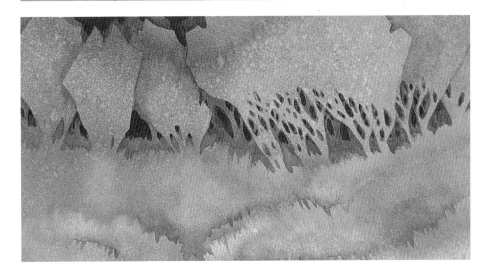

You can speed drying between each layer with a handheld hair dryer.

8 TURN ON THE LIGHT

To capture a warm glow behind the trees you will need to reintroduce the light. When working in the negative, this is easily accomplished by lifting color or applying a light-valued opaque watercolor, gouache or acrylic gouache. Paint in a sparkling pattern of tiny lights that glisten between the branches with Pale Peach or Ivory White acrylic gouache that has been tinted with Quinacridone Violet to repeat and connect the pinks found in the foreground. Apply the opaque paint with an old brush and be sure to clean it with soap immediately after use.

9 BLEND AND DIFFUSE

Soften any overly hard edges by gently scrubbing and lifting. When dry, rub a little pink chalk pastel into the lifted patches. To enhance the surface glow in the areas of interest, use pink, light blue and ochre pastel to catch a rim of color along the edge of the tree tops and on the tips of the grasses. Subdue any raw or white areas that detract from the gentle glow with pastel or a tint of watercolor. Blend harsh marks with a paper stump and remove undesirable pastel with a soft eraser.

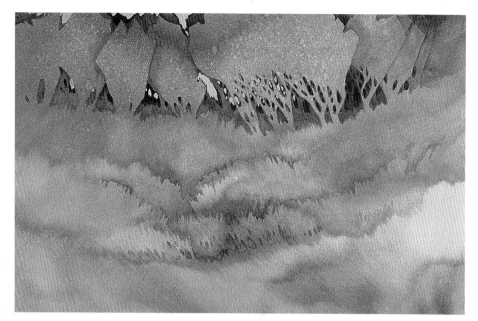

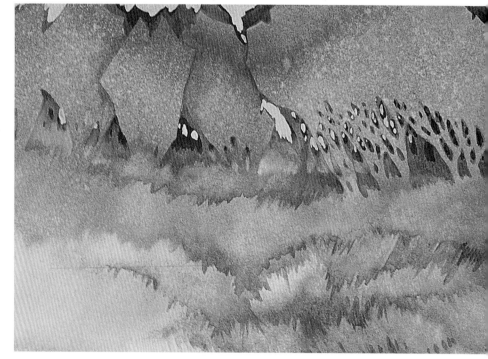

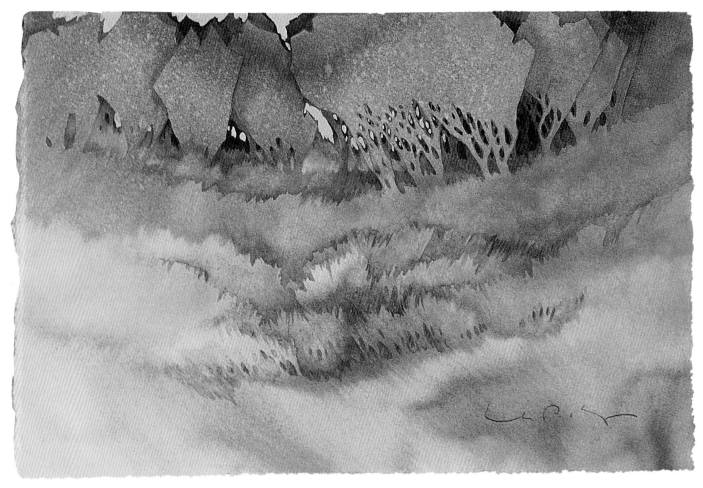

A MOMENT OF QUIET SOLACE
Mixed Medium
11" × 8" (28cm x 20cm)

Mixing Mediums

It's not against the law to mix your mediums.
When pastel, acrylic, water-soluble inks or other
mediums are combined with watercolor they may
be categorized under a variety of labels such as
mixed medium, watermedia or water-based
media. If you choose to submit such a work to an
exhibition, just be sure the rules allow for a
broader definition. Some organizations are open
in their interpretation of watercolor, but if the call
for entry specifies transparent watercolor only
then hold back your piece for a show that allows
for a wider scope.

conclusion—the artistic journey

Growing as an artist is a lifelong journey. Art isn't merely something we do to occupy time. It involves where we come from, who we are, and where we're headed. When you choose to follow a pathway of creativity, you will need to take along your intellect and intuition as well as a mastery of materials and techniques. Set off with an overall plan, and then refine your vision and expertise through practice and commitment to achieving your goals. Only you can decide how important art is in your life. No matter how supportive others may be, you must make a resolution to yourself, and take the time to work at your art. Honesty, sincerity and the creative inner spirit will guide the way, because the best paintings come from the voice within. You needn't feel guilty about being a bit self-indulgent. Dedicated pursuit toward the fulfillment of the desire to express yourself in innovative and sincere ways will lead to true satisfaction, because art is a vital part of who you are.

Only you know whether you paint just to make yourself happy, learn, express your inner feelings, explore or to develop as an artist. Only by following your heart can you satisfy your need. It feels wonderful when other people praise your artwork, and it can be hard to resist friends, family, gallery and customer's suggestions about what and how you should paint. But don't paint to please anyone but yourself.

Contentment and happiness come from pursuing your personal desires and unique quest, not someone else's idea of it. Forget about selling, winning awards, and exhibiting while you are working on a painting. Focus on the process of painting. Work to convey your personal artistic intent.

While it is less threatening to play it safe by repeating successful painting techniques and concepts, it is essential that you reach outside of your comfort zone to try a new approach to expand your artistic vision and stretch your creativity. Even when the struggle leaves you confused or with a terrible mess, rest assured that you will learn from both the

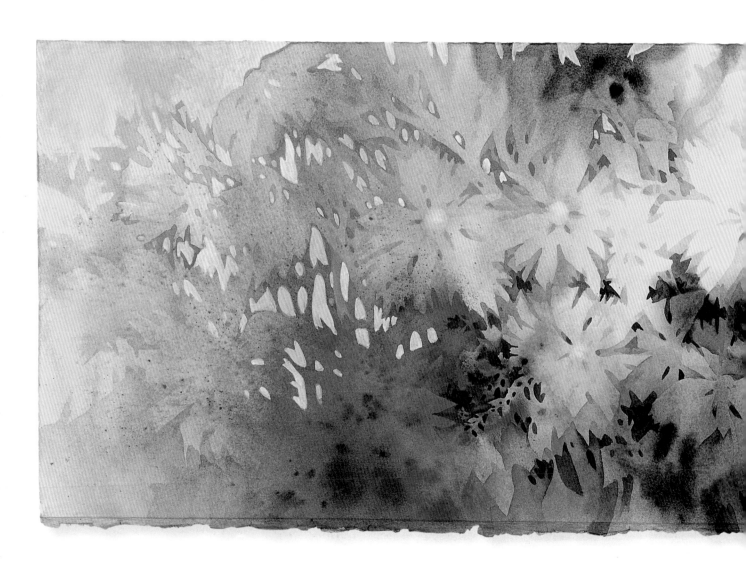

successes and the failures. Problem solving is a great way to advance your skills. When you are faced with a seemingly insolvable challenge, instead of abandoning the painting, work through it. Don't give up, you can do it! As difficult as it may be, try to see frustrations and disasters as opportunities to solve a mystery or to develop a new technique. The goal is to learn something from every painting. Remember what works, and build upon that. Your artwork will naturally improve when you take what you have learned from one painting to the next. The good news is that although the progress may be slow at times, your paintings will improve. Count on that!

Thinking and seeing in an altogether different way is not an easy task. You've been viewing the world around you in your own particular way your entire life. To achieve an alternate way of seeing, you need to be both patient and persistent. Sharing my approach to negative painting is a privilege that brings me exceptional joy. It is a tremendous thrill to hear a student's sudden elated proclamation, "Oh, I get it!" I sincerely hope that you find my ideas intriguing, inspiring and challenging. Once you have made the required leap to seeing in the negative, once you too "get it," you may never see things in the same old way again.

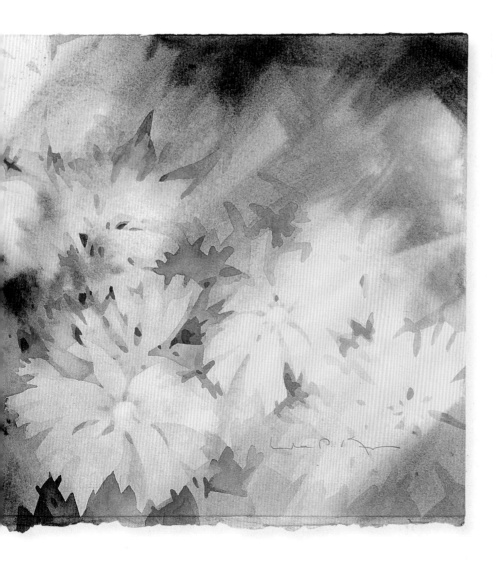

SUMMER BY THIS SUN
Mixed water media
11" × 30" (28cm x 76cm)

reminders and considerations
when building multiple layers in the negative

- Work from the front to the back or fore-ground to background. The objects closest to you are created first.

- Don't attempt to predraw the entire design in the beginning. This will only confuse you. Create just one layer at a time.

- Dry each layer thoroughly before applying the next glaze.

- Remind yourself, I'm not painting the object (leaf, tree, flower, etc.), I'm painting around it.

- Resist the temptation to go back into your shapes to add details and tex-tures or to fill in shapes.

- To help keep track of shapes, pencil them in first, or use cutout paper templates.

- To visualize how a stem might con-nect to a leaf or flower, lay a piece of string on the painting. Adjust the string into a natural curve and note where it weaves through spaces and under shapes. Mark the guideline in pencil. For straight stems, lay a pen-cil on the paper for a guide.

- Remember that as you build layers the color naturally becomes darker and dirtier. Typically the painting will evolve from lightest values to dark-est. How-ever, you have the option of progressing from dark to light by using pigments that will lift as well as opaque watercolor, acrylic or gouache.

- Transparent colors work best for mul-tiple layers of glazing, but don't limit your palette solely to these pig-ments. Opaques can be thinned with water to appear transparent, but bear in mind you will not be able to build as many layers before stirring up mud. Staining pigments are the most powerful, and if you want rich darks you will need them. Stains will dye any layers that you have already laid down and will bleed through subsequent layers you might add.

- If you want to preserve the white of the paper, you need to plan this from the onset, unless you are willing to add opaque white. Personally, I don't worry about saving whites. I prefer a blush of underlying color, enhanced and brightened by the use of con-trasting darker or neutralized colors in adjacent areas and shapes. Similarly, don't hesitate to use solid layers of light opaques. They can be quite exquisite.

- To create color harmony use a limit-ed palette. When building layers on an underpainting, repeat the colors already established. When glazing, consider using a color that is already in the area that you wish to layer. If, for example, you have a section that is a pale blue, try glazing with anoth-er pale or medium blue.

- The color that you use to paint around your shape will be the under-lying color of the next shape defined. Select your color with the knowledge that what-ever you use will be the color for the next set of shapes. You may wish to predetermine your plan. For example, layer in the following manner: (1) green grass, (2) blue water, (3) gray shoreline rocks, (4) dark green maple trees, (5) dark gray sky. In this way you will know to lay down the green first; cut out the upper edge of the grass using blue; define the top level edge of the water with gray, etc.

- As you build your layers make a con-scious decision how the color of your next level will change. Choose from value, hue or intensity of the previous layer.

Creating the Illusion of Space

Overlapping layers and shapes auto-matically suggest depth. To further enhance this illusion, or to compensate, consider the following:

- Warm colors advance while cool col-ors recede.

- Texture is more evident in objects that are closer.

- Transparent colors suggest an airy atmosphere, while opaques sit on the surface and advance.

- Objects appear paler as they move fur-ther into the distance.

To Suggest Deep Space

- Use warm colors in the foreground and cool the color as you move up the page to the background to give the illusion of depth.

- Soften edges as the layers recede.

- Work with transparent colors. Use lim-ited opaques in the foreground only.

To Flatten Space and Create a Contemporary Look

- Use cool colors in the foreground and warm up the background.

- If you use texture, work it into the background as well as into the close objects.

- Opaques used in the background will help to pull these shapes forward.

picture planning worksheet
12 easy steps

Focusing on a particular mood will guide me while making design decisions and planning my painting. Each component adds to achieving the overall effect I wish to convey.

1. The *mood* that I wish to express in this painting is:

2. The *format*—shape and size of paper—that will best suit this mood is (choose as many as needed): large or small, thin or wide, horizontal or vertical, square, round

3. The *shapes* that best express this mood are (choose one): round, square, triangular—adaptations and combinations will be incorporated

4. The *size* of the shapes will be predominately small, medium or large

5. *Color relationship*—(choose one as dominant):
 a. Value relationship—paintings are organized around shifts in value, light to dark
 b. Hue relationships—the interplay between the hues
 c. Intensity relationships—the alternation of clean and neutralized color
 d. Symbolic association—e.g., red/romance, white/purity

 If you selected hue relationships, choose to work with either: complementary, analogous, or warms and cools

6. *Colors selected* are:

7. *Brushwork*—(choose one): large and loose, painterly (brushwork and marks visible), casual (little attention given to brushwork) or carefully rendered

8. *Textures*—(choose one): little or none, moderate, highly textured

 If you selected moderate or high, choose as required from: hard, soft, smooth, rough, experimental

9. *Edges*—(predominantly): hard or soft (you can still combine lost and found, but choose one to be dominant)

10. *Activity level*—(choose a ratio such as): two-thirds active and one-third passive, or two-thirds passive and one-third active

11. *Attention seeking devices* for the areas of interest (choose one type of color conflict as dominant): contrast of value, contrast of hue, contrast of intensity

 If you selected hue, choose: complementary or warm vs. cool

12. *Draw a small diagram* in the proportions of your chosen format. Mark on your diagram:
 a. Primary line of movement in red, secondary line in blue (if required to balance)—Choose from: curvilinear, zigzag/diagonal, straight, horizontal, vertical or combined horizontal and vertical
 b. Main area of interest, secondary areas of focus in yellow (consider placement, balance, size and closure)

13. *Other great ideas* you want to incorporate

Photocopy and complete this worksheet to make picture planning easy.

index

the best art instruction comes from north light books!

Take advantage of the transparent, fluid qualities of watercolor to create startling works of art that glow with color and light! Jan Fabian Wallake shows you how to master special pouring techniques that allow pigments to run free across the paper. There's no need to worry about losing control or making mistakes. Wallake empowers you to trust your instincts and create glazes rich in depth and luminosity.

ISBN-13: 978-1-58180-487-4
ISBN-10: 1-58180-487-3, PAPERBACK, 128 PAGES, #32825

Penny Soto shows you how to add emotion, drama and excitement to your work with color. By following her simple step-by-step instructions, you'll learn how to combine and juxtapose hues to create vibrant paintings. You'll also discover the many personalities of color, plus techniques for capturing light, shadow, and reflections in water.

ISBN-13: 978-1-58180-215-3
ISBN-10: 1-58180-215-3, HARDCOVER, 144 PAGES, #31993

Packed with insights, tips and advice, Watercolor Wisdom is a virtual master class in watercolor painting. Jo Taylor illustrates every important technique with examples, sketches and demonstrations, covering everything from brush selection and composition to color mixing and light. You'll learn how to find your personal style, work emotion into your work, understand and create abstract art and more.

ISBN-13: 978-1-58180-240-5
ISBN-10: 1-58180-240-4, HARDCOVER, 176 PAGES, #32018

This book shows you how to develop the skills you need to express yourself no matter what unusual approach your creations call for! Experiment with and explore your favorite medium through dozens of step-by-step mini demos. No matter what your level of skill, *Celebrate Your Creative Self* can help make your artistic dreams a reality!

ISBN-13: 978-1-58180-102-6
ISBN-10: 1-58180-102-5, POB W/CONCEALED WIRE, 144 PAGES, #31790

Watercolor Painting Outside the Lines

A Positive Approach to Negative Painting

Linda Kemp

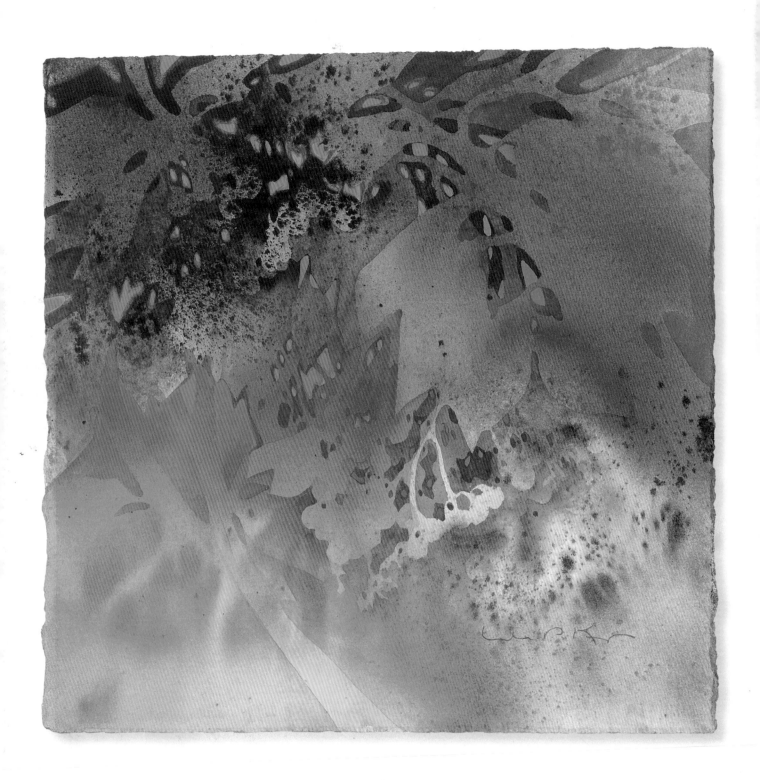

IN THIS NEW LIGHT
Watercolor
11" × 11" (28cm × 28cm)
Collection of Harriet McCaig